IMAGES
*of America*

# EARLY BURBANK

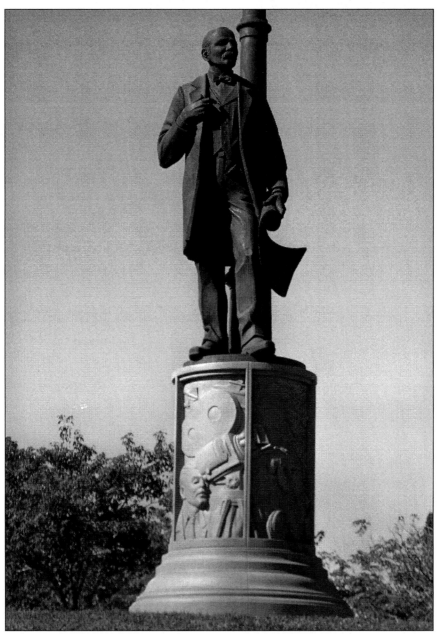

A man of many trades, Dr. David Burbank was a professional dentist, an accomplished sheep rancher, and a savvy real estate investor. At 1075 West Burbank Boulevard, located at the intersection known as Five Points, stands a 12-foot bronze sculpture of Dr. Burbank, founder of the city. The sculpture was unveiled on January 12, 2010. (The authors.)

ON THE COVER: In the early 20th century, movie shoots took place on land previously owned by Dr. David Burbank. In this 1925 photograph, a film crew poses at the back of the ranch house once owned by Dr. David Burbank. The house was part of the Warner Bros. lot from 1928 until the 1950s. (The Burbank Historical Society.)

# IMAGES
*of America*

# EARLY BURBANK

Erin K. Schonauer and
Jamie C. Schonauer

ARCADIA
PUBLISHING

Published by Arcadia Publishing
Charleston, South Carolina

Printed in the United States of America

Library of Congress Control Number: 2013947851

For all general information, please contact Arcadia Publishing:
Telephone 843-853-2070
Fax 843-853-0044
E-mail sales@arcadiapublishing.com
For customer service and orders:
Toll-Free 1-888-313-2665

Visit us on the Internet at www.arcadiapublishing.com

*To Burbankers of the past, present, and future*

# CONTENTS

# ACKNOWLEDGMENTS

Many people have helped us along the way in our journey to capture just some of the plentiful pieces of Burbank's intriguing history. Thank you to Mike McDaniel and Wes Clark for allowing us to use vintage photographs from their historically rich website, Burbankia. Many thanks to the Burbank Tournament of Roses Association and its historian, Erik C. Andersen, who provided unlimited access to its archives and shared his wealth of knowledge with us. Thank you to Ron Dickson for sharing aviation images from his informative website, GoDickson.com, and to the Burbank Aviation Museum group for its efforts to preserve aviation history. We would like to thank the knowledgeable staff at the Burbank Public Libraries, the Margaret Herrick Library, and the Burbank Historical Society. Our gratitude goes to Ceci Stratford, Stacie Vournas, Jackie Forsting, Daniel MacPherson, Fermer Kellogg, Lansing White, Gayle Migden, Susan Miceli, Marva Felchlin, and Emma Jeane Starre. We appreciate all of your generosity and time. We would also like to send a sincere thank you to our editor, Jared Nelson, for his positive encouragement and guidance. And a very special thank you to our mom and dad for their continuous love and support.

Unless otherwise indicated, images are part of the authors' collection. Other images appear courtesy of the following sources: Wes Clark and Mike McDaniel's Burbankia (WC,MM/Burbankia); Burbank Tournament of Roses Association (BTORA); Burbank Historical Society (BHS); Burbank Aviation Museum (BAM), GoDickson.com/Aviation History of the San Fernando Valley (AHSFV); and photograph by Erin K. and Jamie C. Schonauer (EJS).

# INTRODUCTION

"Burbank is a very historical town," said Johnny Carson in his 1983 *Tonight Show* monologue. "A lot of people think it was named after Luther Burbank. It was named after, I think, a fellow by the name of David Burbank, who was a dentist. And he came out and said this is a great place to have a toothache."

Carson's Burbank jokes became part of his late night repertoire, and this one has a twinkle of truth. Dr. Burbank, in fact, is the pioneering dentist for whom the city is named. In the early 1850s, Dr. Burbank, a New Hampshire native, traveled across the country by horseback and covered wagon. A new landscape awaited him across the vast plains and rugged mountains. Following trails marked by gold seekers, Dr. Burbank finally reached his destination—the California coast. Upon arriving in San Francisco in the mid-1850s, he set up his dentistry practice. He left San Francisco shortly after the Civil War and arrived in Los Angeles in 1867. That same year, Dr. Burbank purchased over 9,000 acres of land in the San Fernando Valley, which included Rancho San Rafael and Rancho Providencia. The two ranchos became one, and today, this land is Burbank.

In the 18th century, before Dr. David Burbank, the land on which the city sits belonged to Spanish dons. In 1798, José Maria Verdugo acquired Rancho San Rafael through a Spanish land grant that included a considerable area of present-day Burbank. Rancho Providencia was located to the west of Rancho San Rafael. Rancho Providencia, created after Mexico declared its independence from Spain in the early 1820s, was granted to Comandante J. Castro, Luis Arenas, and Vincente de la Ossa.

In the 1850s, Americans began to settle in the ranchos. The first Americans to own land in Burbank were David W. Alexander and Alexander Bell, who purchased approximately 4,600 acres of Rancho Providencia from Vincente de la Ossa in 1851. In 1857, Missouri native Jonathan R. Scott acquired 4,603 acres of Rancho San Rafael from Julio and Catalina Verdugo, who inherited the land from their father, José Maria Verdugo. Dr. Burbank purchased Rancho San Rafael from Scott and Rancho Providencia from Alexander and Bell in 1867. After owning and cultivating the two ranchos for nearly 20 years, Dr. Burbank sold his acreage to the Providencia Land, Water and Development Company in 1886.

The land, beautifully located among the Verdugo Mountains, occupied the eastern section of the San Fernando Valley. The Providencia Land, Water and Development Company put the fertile farmland up for sale on May 1, 1887, the same day Burbank was founded.

On July 8, 1911, Burbank officially became a city—the first in the San Fernando Valley. The city began to quickly develop: houses were numbered, streets were named, electricity powered street lights and homes, and the city marshal's office became responsible for law enforcement. In 1913, the city opened its first library, fire department, and public service department (Burbank Water and Power). Three years later, the city constructed its first city hall.

As the community grew, so did Burbank's businesses. By 1917, manufacturing began to thrive as farming faded. Prolific companies set up shop, including the Moreland Motor Truck Company;

Empire China Company; Libby, McNeill and Libby; Andrew Jergens Company; Mission Glass Company; and Paramount Dairy.

Movie houses also beckoned those wanting to spend time out on the town. In 1919, the Loma Theatre opened at 319 East San Fernando Boulevard and proudly advertised films from stars like John Barrymore, Mary Pickford, and Gloria Swanson. Admission was 10¢, and moviegoers could purchase candies from the theater's sweet shop for 5¢. On August 2, 1919, the Victory Theatre opened at 205 East San Fernando Boulevard. Mr. Myers, who managed the theater in the late 1920s, said his playhouse would provide Burbank with "only the best in pictures for the entire family at popular prices."

Besides catching a film, locals could listen to music, literature, and dramas on Burbank's first radio station, KELW. Owner Earl L. White, who founded the station in 1927, made a commitment to serve the city and an effort to connect with the locals. "You and your friends are invited to come to the studio any time," was the motto spread by White and his station in the 1928 booklet *Your Burbank Home*.

In 1926, the city welcomed its first big film studio when First National Pictures broke ground on Olive Avenue near Dark Canyon Road. Warner Bros. purchased First National Pictures in 1928, gaining access to the large studio, its backlot, and stars such as Colleen Moore, Loretta Young, and Douglas Fairbanks.

With Hollywood stars filming in town, aviation stars soon took to Burbank skies. In 1928, the Lockheed Aircraft Company moved its facilities from a small Hollywood garage to a 20,000-square-foot Burbank factory at San Fernando Boulevard and Empire Avenue. Aviation royalty such as Amelia Earhart, Wiley Post, Laura Ingalls, Charles Lindbergh, Bobbi Trout, and Frank Hawks all entered the record books while flying Lockheed planes.

Meanwhile, Burbank's ample acreage and proximity to Hollywood was attracting more entertainment industries. Columbia Pictures, looking for space to build exterior sets, bought 40 acres of land at Hollywood Way and Oak Street in 1934. The site, called Columbia Ranch, occupied the former Burbank Motion Picture Stables.

The expansive 51-acre plot at Buena Vista Street and Riverside Drive lured the Walt Disney Studios to Burbank in 1939. Besides producing animated hits such as *Pinocchio* and *Fantasia* in the new Burbank studios, Disney also lent a hand in the war effort. During World War II, artists and set designers helped camouflage the Lockheed Aircraft Company facilities to look like a farm field in an effort to divert enemy attacks. Disney also produced training films for the Lockheed Aircraft Company; *Four Methods of Flush Riveting* (1941) was one of many instructional films created by the studio.

In October 1952, NBC opened its headquarters at Olive and Alameda Avenues. To kick off its opening, NBC broadcast the *All Star Revue* from studio one to the nation—Milton Berle, Dinah Shore, and Red Skelton all made guest appearances. In 1955, NBC expanded by completing its state-of-the-art television studios, Color City. Many top-rated shows came from the studios, including *The Tonight Show Starring Johnny Carson*, where the phrase "Beautiful Downtown Burbank™," which originated on *Rowan and Martin's Laugh-In*, became the source of much comedic banter. Carson's pokes at the city brought national recognition to Burbank, and his show lured flocks of tourists to the once-rural town dotted with ranch houses, stretches of dirt roads, and fruitful farmlands that Dr. Burbank called home over a century ago.

# One

# THE GEM OF THE SAN FERNANDO VALLEY

In September 1887, the *Los Angeles Times* promoted early Burbank as "The Gem of the San Fernando Valley," boasting of "its fine climate and rich soil," ample water supply, serene views among 17,000 acres of the Providencia ranch, and mere six-mile distance from the city limits of Los Angeles. The acreage, composed of foothill and valley land among the Verdugo Mountains, occupied both sides of the Southern Pacific Railroad. People across the nation migrated west to explore Burbank's land and its advertised amenities. The prime real estate officially went up for sale on May 1, 1887, the same day on which Burbank was founded and became a town. The Providencia Land, Water and Development Company began to sell property for $200 to $500 an acre in increments that mostly consisted of 20- to 40-acre farms. These lush farms became famous for growing a number of fruitful crops, including cantaloupes, grapes, and alfalfa.

In 1867, just 20 years prior to the land boom, Dr. David Burbank, a New Hampshire–born dentist, saw the land's potential when he stepped foot on the California property that would eventually be named after him. He bought over 9,000 acres of land in the Rancho Providencia and Rancho San Rafael. It was not until 1871 that Dr. Burbank gained clear land titles of both ranchos. This was after a lengthy court case called "the Great Partition," which defined the unclear boundaries of early Verdugo Spanish land grants. In the end, Dr. Burbank's original purchase and acreage were confirmed. In 1886, he sold his acreage—for $250,000—to the Providencia Land, Water and Development Company, where he became a director and was influential in developing "The Gem's" fine land.

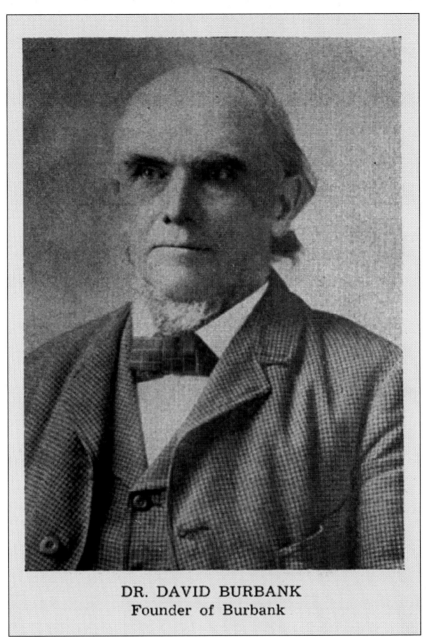

**DR. DAVID BURBANK**
Founder of Burbank

Dr. David Burbank (1821–1895), while in his 30s, migrated west to California. When Dr. Burbank arrived in the pueblo of Los Angeles in 1867, life was primitive, with adobe houses, dirt roads, and stables. A 10-pound turkey cost 50¢; fish was no more than 5¢ per pound, and steaks cost a mere 7¢–10¢ per pound. After arriving in Los Angeles, Dr. Burbank purchased over 9,000 acres of land—including 4,603 acres of Rancho San Rafael from Jonathan R. Scott and 4,600 acres of Rancho Providencia from David W. Alexander and Alexander Bell—for about $1 per acre. These two ranchos later became the town of Burbank. In 1886, after nearly 20 years of success as a sheep rancher, Dr. Burbank sold his land to the Providencia Land, Water and Development Company for $250,000. Some say a drought hit, depleting Dr. Burbank's grass and much of his flock, leading to his decision to sell his parcel of land. (WC,MM/Burbankia.)

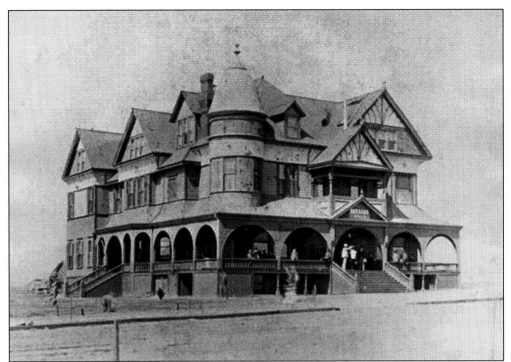

Burbank was founded on May 1, 1887, and land officially went up for sale. The Burbank Villa, built in 1887 by Dr. David Burbank and his son-in-law, John Griffin, offered a place for potential buyers to stay. Built for $30,000, the villa boasted deluxe accommodations, including 70 rooms, a large reception hall, and a reading room. (WC,MM/Burbankia.)

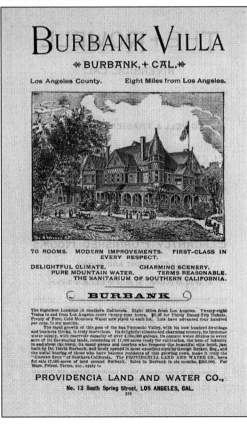

This late-1800s Burbank Villa advertisement lured land buyers to town by highlighting the area's "charming scenery" and "pure mountain water." Rooms cost $2 to $3 per day, with weekly rates starting at $10. The Burbank Villa, located at 135 East Olive Avenue (the present-day site of the Bob Hope Post Office), later became known as the Santa Rosa Hotel, which was run by May Clarke. (WC,MM/Burbankia.)

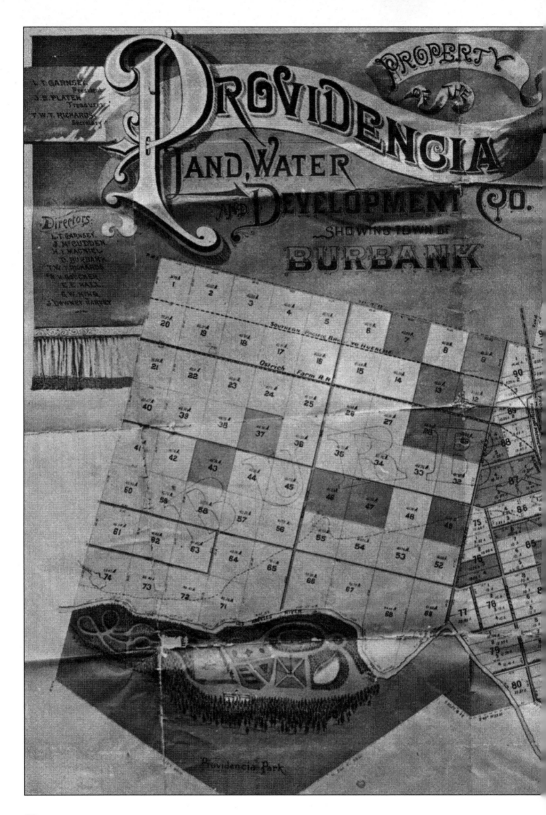

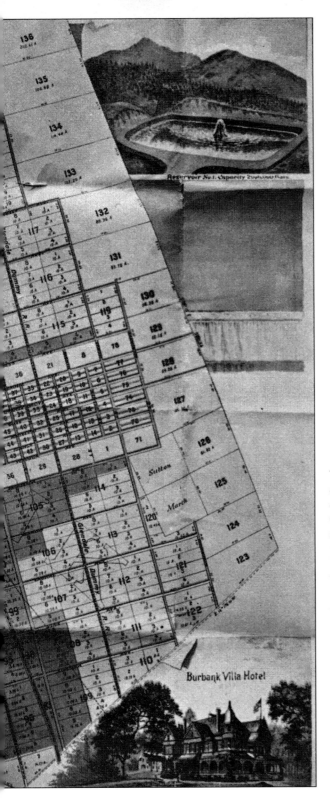

Reservoir No.1. Capacity 2000,000 Gals.

Burbank Villa Hotel

This c. 1887 plat map features over 100 plots of Burbank land divided and ready for sale. Pres. L.T. Garnsey, treasurer J.E. Plater, and secretary T.W.T. Richards headed the Providencia Land, Water and Development Company, which was responsible for early land sales in Burbank. The directors of the company were L.T. Garnsey, J. McCudden, H.I. Macniel, David Burbank, T.W.T. Richards, W.H. Goucher, E.E. Hall, G.W. King, and J. Downey Harvey. Before the end of 1887, the Providencia Land, Water and Development Company earned $475,000 from land sales. On April 3, 1887, an ad in the *Los Angeles Tribune* promoted Burbank's robust, bountiful acreage as "the finest body of land in Los Angeles County." (WC,MM/Burbankia.)

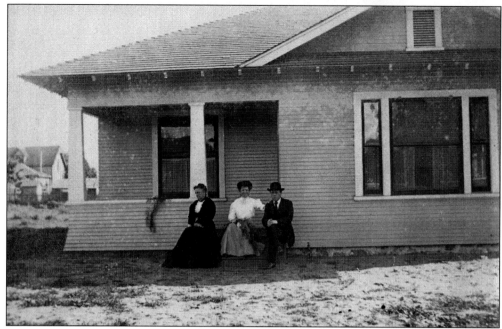

Three unidentified Burbankers enjoy the winter climate as they sit on the front porch of a ranch house in this photograph from January 3, 1909. "Burbankers"—the name given to Burbank residents—can be traced back to November 30, 1889, when it was printed in the *Burbank Times*. (WC,MM/Burbankia.)

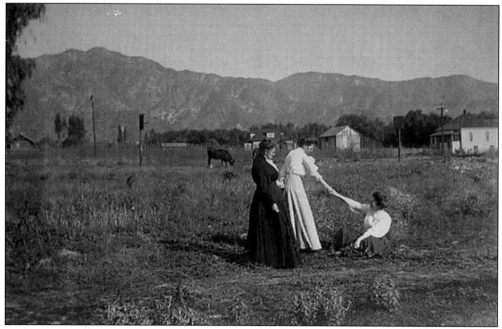

In this January 3, 1909, photograph, two Burbankers lend a hand to another in the farmland that filled the town's landscape in the early 1900s. Cattle roamed the fields, while cantaloupes, strawberries, grains, and alfalfa thrived in the Burbank soil. This photograph was taken near the corner of Olive Avenue and First Street. (WC,MM/Burbankia.)

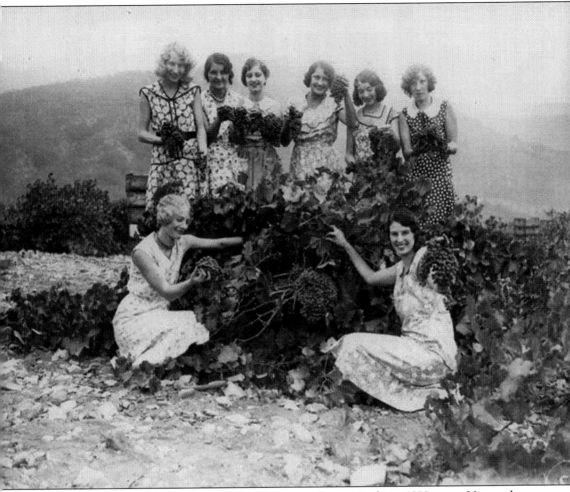

A group of eight unidentified women poses with an array of grapes in this c. 1928 image. Vineyards thrived in the late 1800s and early 1900s. In 1862, American landowner Jonathan R. Scott sowed vineyards on portions of his land, Rancho San Rafael (which later became part of Burbank). This was the lucrative beginning of the city's grape industry. Even during the harsh drought that hit the area from about 1889 to 1896, vineyards flourished thanks to natural underground wells. With this advantage, Burbank hosted world-class vineyards and wineries including McClure Winery, Brusso Winery, and Gai's Winery. (WC,MM/Burbankia.)

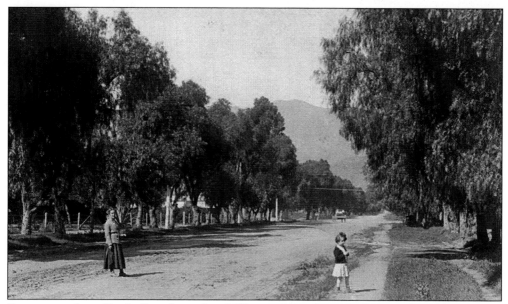

Pepper trees planted by the Providencia Land, Water and Development Company line Olive Avenue in this c. 1910 photograph. In September 1911, Olive Avenue was the site of a gala celebrating the first Pacific Electric car to pass through Burbank over the Glenoaks Boulevard tracks. The Burbank Chamber of Commerce coined the slogan "Burbank—45 minutes from Broadway" because the "red car" offered a considerably faster route to Los Angeles than a traditional horse and buggy. (WC,MM/Burbankia.)

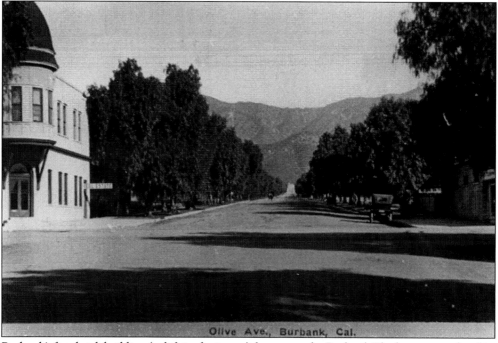

Burbank's first brick building (at left in the image), known as the Burbank Block, was completed in 1888 at the corner of San Fernando Boulevard and Olive Avenue. At one point, it housed the Burbank Post Office, a bakery, a market, and a barbershop simultaneously. (WC,MM/Burbankia.)

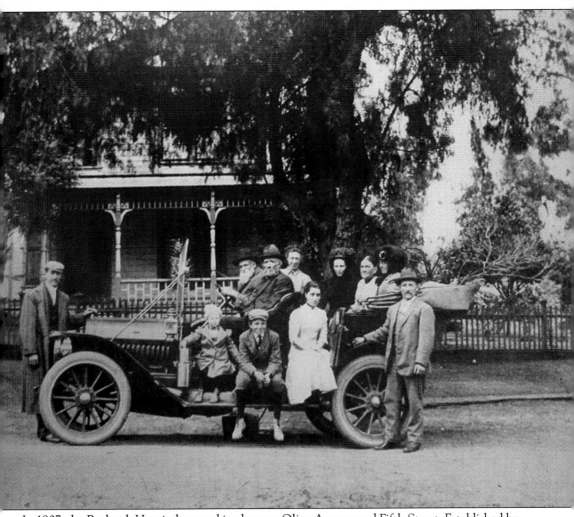

In 1907, the Burbank Hospital opened its doors at Olive Avenue and Fifth Street. Established by Dr. Elmer H. Thompson, a Wisconsin native who came to Burbank in 1905, the small hospital (pictured here) occupied a two-story house and was equipped with 16 beds. By 1925, the hospital had grown to include 50 beds. Thompson's sister, Ethel (at right in white dress), served as head nurse. (WC,MM/Burbankia.)

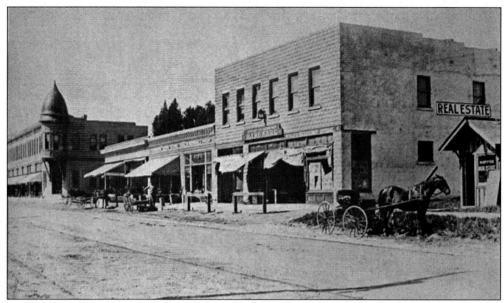

The c. 1913 image above shows a paved section of San Fernando Boulevard, which was completed around 1910. Before that time, San Fernando Boulevard was merely a dirt road—and a popular thoroughfare for herds of sheep, which were known to kick up dust, causing problems for Burbank State Bank. To prevent his business from closing, Ralph Church, who ran Burbank State Bank, (the city's first bank) routinely closed the windows when herds of sheep passed through. The photograph below shows A.O. Kendall's Department Store. A.O. Kendall also served as the original vice president of Burbank State Bank in 1908. (Both, WC,MM/Burbankia.)

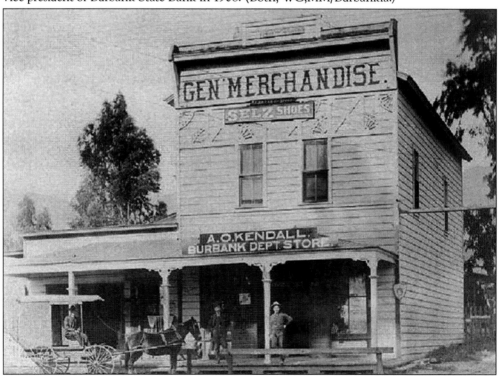

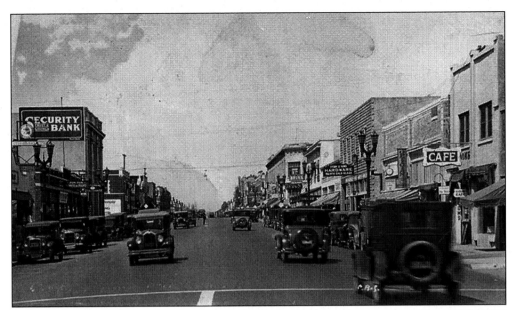

A flock of cars lines San Fernando Boulevard in the c. 1928 image above, offering quite a contrast from the early 1920s, when a local shopper, Mrs. C.R. Stearns, spotted just one car parked on San Fernando Boulevard, as noted in Jackson Mayers's book *Burbank History*. In 1921, San Fernando Boulevard, Olive Avenue, and Magnolia Boulevard were the only paved streets in the city. By 1928, 153 miles of Burbank's streets were paved, and Ford Model Ts inundated the downtown area. Story & Sons, located at 120–124 East San Fernando Boulevard, was one of many businesses in town. Owner Thomas Story established the hardware store in 1915 and ran it with his sons Henry and Walter. In 1911, Thomas Story became Burbank's first mayor. The Story & Sons advertisement at right was printed in *Your Burbank Home* in 1928. (Above, WC,MM/ Burbankia; right, Burbank Merchants' Association.)

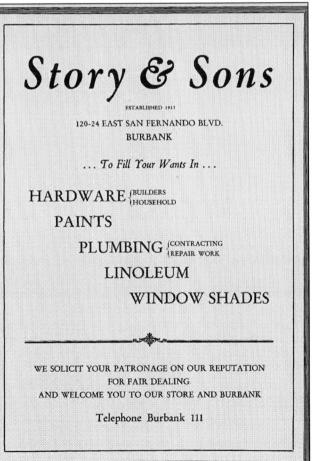

19

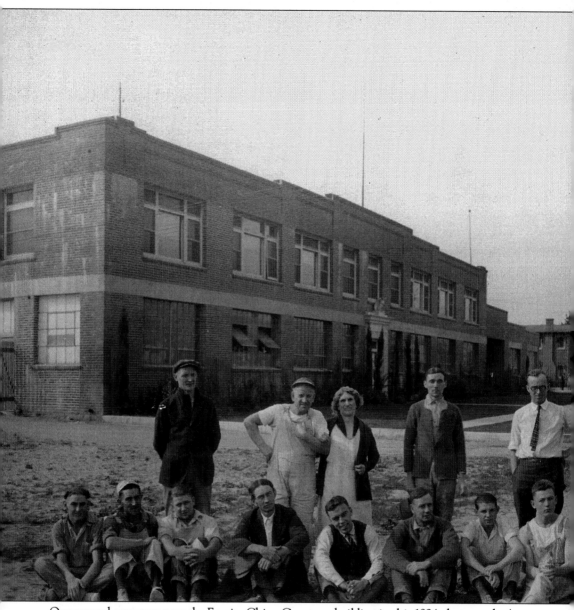

Owners and crew pose near the Empire China Company building in this 1924 photograph. Among the staff is Arch Kellogg (far right, in white uniform), who left a pottery apprenticeship on the East Coast to work for the Empire China Company until the Depression. The factory had seven large kilns used for firing pottery. Early Lockheed pilots often used the kilns as landmarks to help locate

the neighboring Lockheed runway prior to landing. After several years of instability, the Empire China Company went out of business due to a conflict between its stockholders. The factory stood on North Victory Place at the present-day site of the Empire Center. (Fermer Kellogg.)

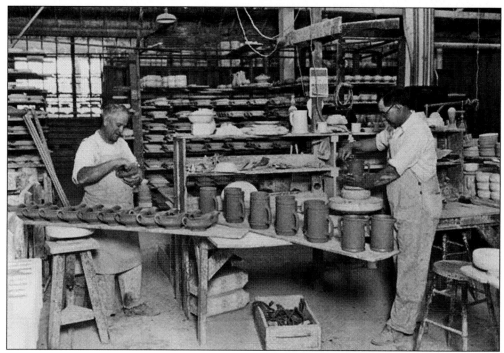

The April 19, 1928, photograph above shows the inner workings of the Empire China Company as two craftsmen hand-make pitchers, gravy boats, and assorted dinnerware to be fired in one of the company's seven kilns. The vibrations of low-flying planes from the neighboring Lockheed Aircraft Company would often shake the dishes in the kilns, breaking them into pieces. Below, factory workers inspect and clean hundreds of dishes before readying them for shipment. (Both, WC,MM/Burbankia.)

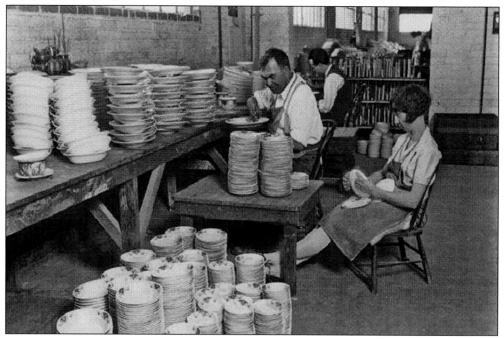

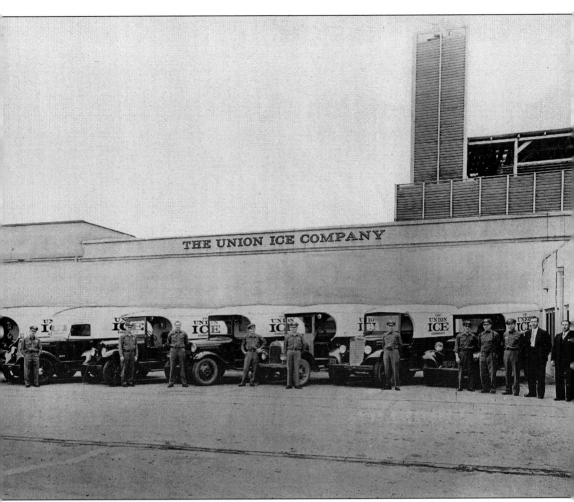

Two managers in suits (far right) and deliverymen—including Arch Kellogg (sixth from right)—pose with trucks in front of the Union Ice Company in this image from the early 1930s. Located at 72 Angeleno Street, the company made 300-pound ice blocks that were stored in metal containers until workers broke the ice into 25- to 50-pound blocks for delivery. With one phone call, to Charleston 6-3115, ice would be on its way. (Fermer Kellogg.)

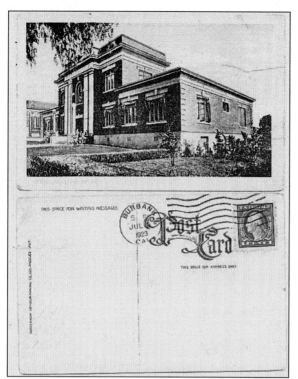

This 1¢ postcard, postmarked July 9, 1923, shows Burbank's first city hall, which was built in 1916 on Olive Avenue and Third Street. The building, made of rug brick and white trim, cost $13,340 and stood until it was demolished in 1959. (WC,MM/Burbankia.)

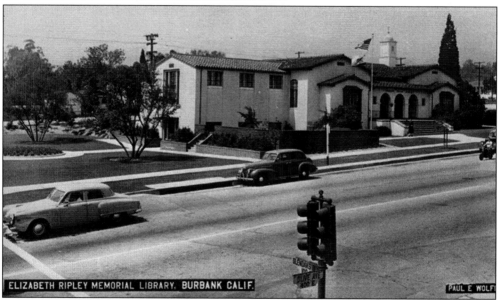

ELIZABETH RIPLEY MEMORIAL LIBRARY, BURBANK CALIF.　　PAUL E WOLF

Burbank opened its first library in 1913 as a contracted branch of the Los Angeles County Library. The library was open for two hours per week and shared space with the "Library of the Brotherhood" at San Fernando Boulevard and Olive Avenue. In 1935, Burbank built a new library (pictured) at Glenoaks Boulevard and Olive Avenue for $33,000. In June 1930, Elizabeth Ripley became the city librarian, succeeding Elizabeth Knox; after Ripley retired in 1952, the Burbank City Council passed a resolution to change the library's name in honor of Ripley's decades of service to Burbank. (WC,MM/Burbankia; photograph by Paul E. Wolfe.)

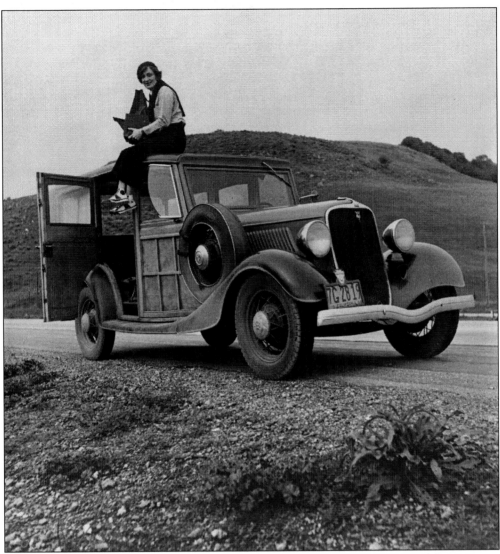

In order to chronicle the Great Depression and its effect on farming, the Farm Security Administration (FSA), part of the US Department of Agriculture, hired photographers like Dorothea Lange (1895–1965), pictured here atop her Ford in California, to capture life across the United States. Lange documented the city of Burbank in 1936, and the following four photographs are images she created during that time. Lange traveled thousands of miles in her car while chronicling America's struggles. Lange was born in Hoboken, New Jersey, and studied photography in New York City before World War I. "Photography," Lange said, "takes an instant out of time, altering life by holding it still." (Library of Congress.)

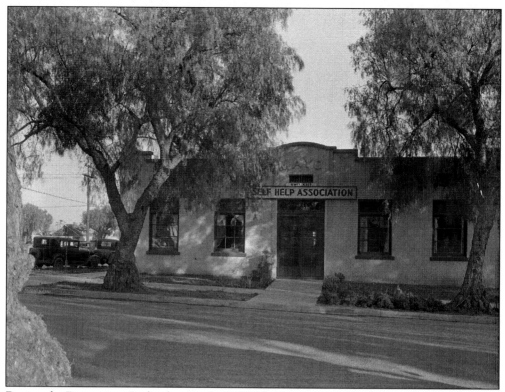

During the Depression, Burbank started a Self Help Association in order to aid those who were hungry and out-of-work. This Dorothea Lange photograph, taken in February 1936, shows the association's building. Members of Burbank's Cooperative Relief Association helped organize the Self Help Association in August 1934. (Library of Congress.)

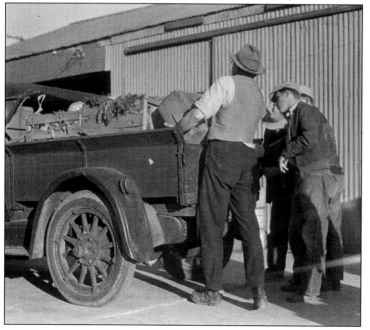

Gentlemen unload groceries at Burbank's Self Help Association in this February 1936 image. Vegetables and fruits such as squash, tomatoes, melons, and potatoes were grown locally to feed its members. In January 1935, the Self Help Association received a federal farm grant of $1,716 to run two parcels of land: one at Hollywood Way and Victory Boulevard and the other on Burbank Boulevard. (Library of Congress.)

An unidentified man sits atop an empty vegetable crate in this February 1936 photograph. By 1936, the Self Help Association had 76 members. A 180-acre farm produced homegrown vegetables, while an outsourced dairy farm, which housed 65 cows, produced 120 gallons of milk per day. (Library of Congress.)

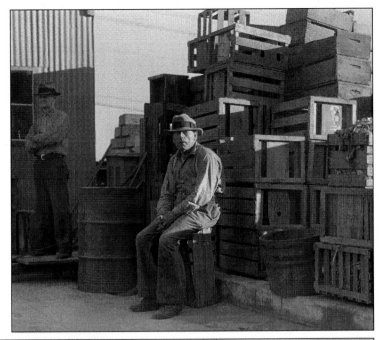

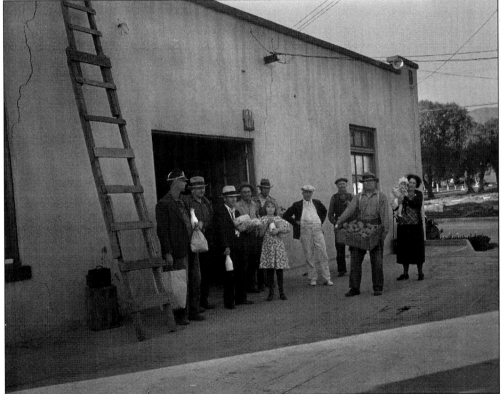

Citizens, holding milk and vegetables, stand outside the Self Help Association in February 1936. The co-op offered the jobless a place to trade work for food; for instance, a skilled barber would give haircuts in exchange for groceries. (Library of Congress.)

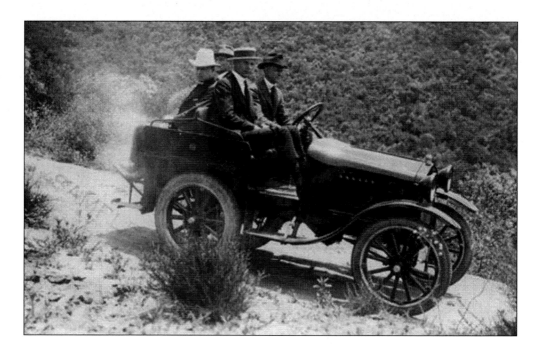

In the early 1920s image above, four unidentified men enjoy the fresh air as they travel along Country Club Drive in a Model T. Country Club Drive, amid Burbank's hills, was built in the 1920s. The drive allowed access to the Sunset Canyon Country Club, as well as a number of cabins available to its members. Below, a Sylvan cabin is nestled in the trees along Country Club Drive. In 1927, a fire broke out, destroying many of the cabins lining the drive. (Both, WC,MM/Burbankia.)

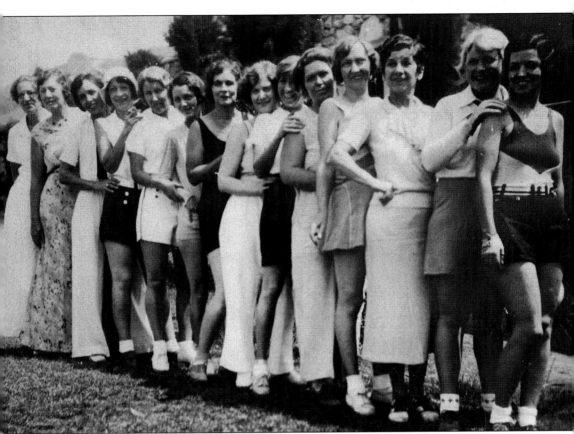

A group of female patrons poses on the grounds of the Sunset Canyon Country Club in 1932. The club opened in 1921, and its acreage, located among the Verdugo Mountains, was annexed to the city of Burbank in January 1926. The club offered golfing and swimming to its members. An article in the 1928 booklet *Your Burbank Home* describes the club's golf course as being "in a climate which makes golf possible twelve months of the year, and on fairways cooled by a semi-tropical breeze." (BHS.)

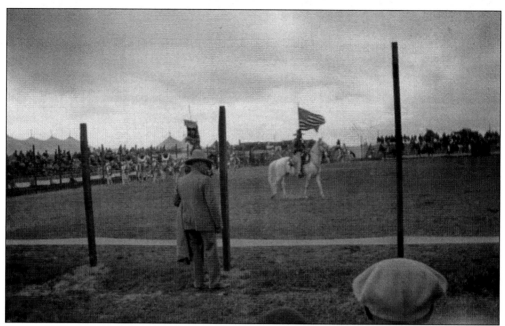

In the 1930 photograph above, 1899 world heavyweight boxing champion James J. Jeffries (1875–1953), nicknamed "the Boilermaker," watches the Elks Club Rodeo at his ranch. Jeffries made Burbank his home in 1904, when he bought a 107-acre ranch located at Victory Boulevard and Buena Vista Street. Besides being an elite boxer, Jeffries hosted a variety of community and charitable events that ranged from Thursday night fight nights in his famous Jeffries barn (which is now displayed at Knott's Berry Farm) to the 1932 Pony Express and Stampede Show (pictured below). (Both, WC,MM/Burbankia.)

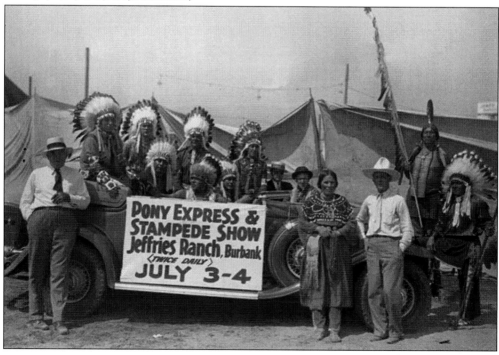

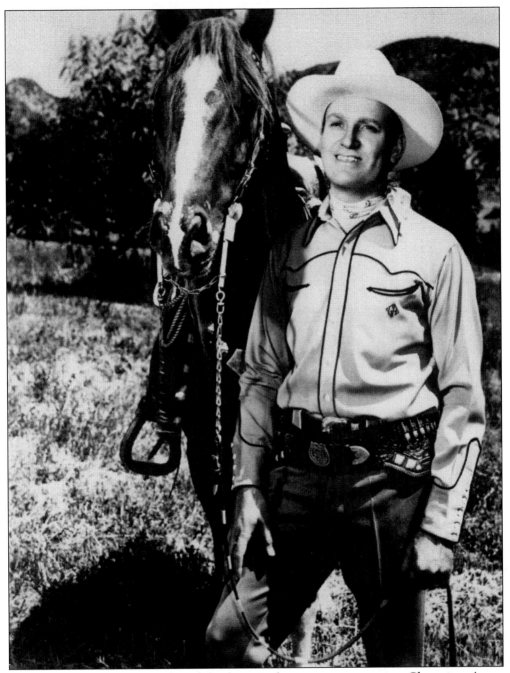

Gene Autry (1907–1998) stands with his horse and movie-star companion, Champion. Autry, "America's Favorite Singing Cowboy," owned land near Olive Avenue Park (now called George Izay Park). In the early 1940s, the city bought several acres of Autry's land in order to expand Olive Avenue Park. Autry's prolific career in the entertainment industry earned him five stars on the Hollywood Walk of Fame.

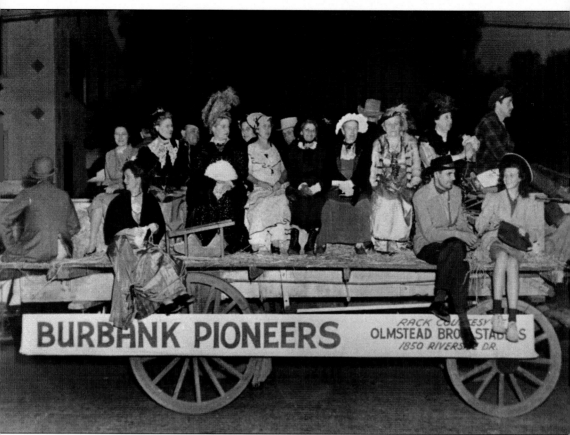

This 1946 image shows a group of Burbank Pioneers taking a hayride on a horse-drawn wagon provided by Olmstead Bros. Stables. According to a December 19, 1947, article in the *Valley Times*, the Burbank Pioneers had 250 members, all of whom had resided in Burbank for at least 35 years. Some of the prominent members included longtime residents Henry Luttge, who lived in Burbank starting in 1893; Fletcher Pomeroy, a resident since 1896; and Emma Fischer, who made Burbank her home in 1894. Burbank's population grew rapidly following the arrival of early pioneers such as Dr. David Burbank. When the city was incorporated on July 8, 1911, the population was merely 500, and by 1940, it had grown to over 34,000. (BHS.)

# Two

# MEDIA MOVES IN

A *Quiet Day in Burbank* filled the screen of the Victory Theatre in the summer of 1919. The 1,000-foot film touted Burbank's unique qualities and points of interest. Although the film was called *A Quiet Day*, as the population rose to nearly 3,000 in 1920, the town was slowly becoming a leading location for the entertainment industry. In 1920, a portion of Stough Ranch, previously owned by Oliver J. Stough, became home to Sacred Films, Inc., which produced Bible scenes helmed by L.B. Taylor. Soon, other genres of film began to use Burbank as a backdrop. Comedians like Fatty Arbuckle could be seen filming in town as early as 1921. Around this same time, movie companies in search of rural locales were drawn to farmland at Third Street and Providencia Avenue.

In 1926, First National Pictures bought nearly 80 acres of the Rancho Providencia, previously owned by Dr. David Burbank. The city gained national recognition as First National shot scenes in town with stars such as Corinne Griffith, Colleen Moore, and Milton Sills. The media buzz amplified in 1928 when Warner Bros.—founded by brothers Jack, Albert, Harry, and Sam—purchased First National Pictures. Before long, Warner Bros. would become one of the world's leading film and television facilities.

In 1934, Columbia Pictures purchased a 40-acre site at Hollywood Way and Oak Street to build exterior sets. In 1939, the Walt Disney Studios moved to Buena Vista Street and Riverside Drive, bringing Disney's world-class animation to town. NBC joined the neighboring industries in 1952 when it relocated from Hollywood to Olive and Alameda Avenues. The network's Color City television studios were the first built from the ground up, and NBC's lineup included *The Tonight Show Starring Johnny Carson*, watched by millions of viewers nationwide. Starting with that small-town showing of *A Quiet Day in Burbank* and continuing with its designation as the thriving "Media Capital of the World," Burbank has truly welcomed the media industry.

In 1927, Earl Loy White established Burbank's first radio station, KELW, using his initials as the call letters. A Kansas native, White moved to Burbank in the early 1900s, where he started a dairy farm and citrus orchard. In 1923, he developed Magnolia Park, a 450-acre tract that blossomed into a booming subdivision complete with its own newspaper, the *Burbank Tribune*, and KELW. White was also responsible for creating Hollywood Way, the street that would help connect Burbank to Hollywood. (Lansing White.)

The KELW antennas pictured at right received and transmitted the 228.9-meter wavelengths on which the station operated. The radio station was located in the "Brick Block" at Magnolia Boulevard and Hollywood Way. At 7:00 p.m. on Saturday, February 12, 1927, KELW owner Earl Loy White made the first broadcast from the 1,000-watt station. While listeners up and down the Pacific Coast could easily tune in, so did those as far away as New York. Will Rogers (1879–1935) was one of many famous voices heard on KELW. A young Rogers is pictured in the 19th-century photograph below. (Right, WC,MM/ Burbankia; below, public domain.)

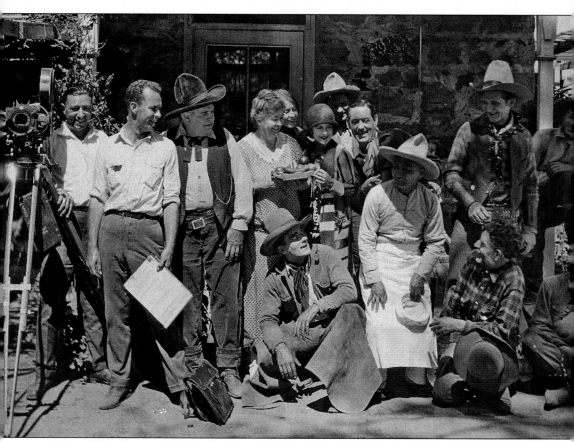

In this 1920s photograph, Mrs. Stephen A. Martin poses with a film crew on Dr. David Burbank's ranch. Mr. and Mrs. Stephen A. Martin, who bought Dr. Burbank's home and ranch, farmed the acreage for many years. In 1926, the Martins sold their land to First National Pictures. The Martins were among the first people to witness First National building the company's studios. After approximately 72 days, the First National studios were completed, and the alfalfa and onion fields that once flourished at the site were transformed for the entertainment industry that was beginning to make Burbank its new home. (BHS.)

First National Pictures built studios on Olive Avenue, near Dark Canyon Road, in 1926 after purchasing nearly 80 acres of land for $1.5 million. The studios featured several large stages and miles of paved streets and produced enough electricity to power a city of approximately 15,000 people. Besides wardrobe and carpentry facilities, they also housed fireproof film vaults. This photograph shows the First National studios in August 1928. (WC,MM/Burbankia.)

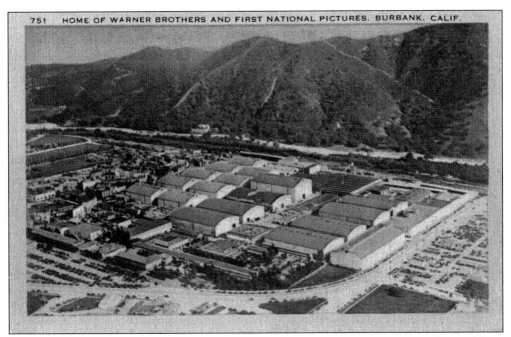

Warner Bros. purchased First National Pictures in 1928. By 1929, Warner Bros. had moved from their Hollywood location to Burbank. This postcard shows an aerial shot of the studios in the 1930s. The back of the postcard says: "More than 70% of the pictures shown throughout the world are produced in Los Angeles County." (Longshaw Card Company.)

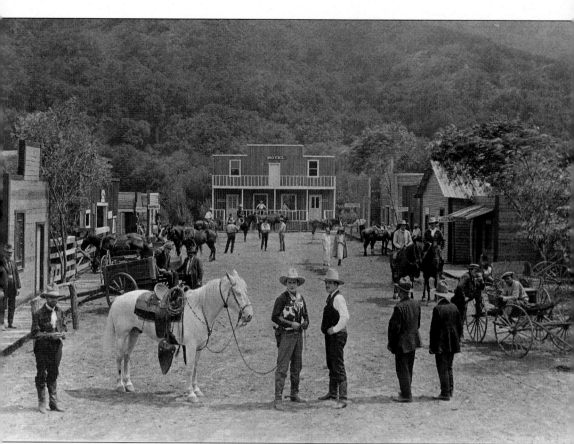

An unidentified cast of cowboys and villagers roams the Warner Bros. Western set in this late-1920s photograph. When Warner Bros. acquired First National Pictures in 1928, the studio gained access to many of their actors, including western star Ken Maynard, who had signed on to star in 18 Westerns for First National in 1926. Maynard showcased his daredevil tricks and stunts in First National films such as *Señor Daredevil* (1926) and *The Red Raiders* (1927). In 1929, Maynard starred in several Warner Bros. Westerns under the First National banner, including *The Lawless Legion*, *Cheyenne*, and *The California Mail*. The late 1930s and 1940s brought about Errol Flynn Westerns, including *Dodge City* (1939) and *San Antonio* (1945). Warner Bros. continued producing Westerns in the 1950s with such films as *The Searchers* (1956), *Shoot-Out at Medicine Bend* (1957), *The Left-Handed Gun* (1958), and *Rio Bravo* (1959). (BHS.)

Here, Jack Warner (1892–1978), in the dark jacket at center, takes part in a production on the Warner Bros. backlot. After the release of the first "talkie" by Warner Bros., *The Jazz Singer* (1927), the company purchased First National Pictures and wired the studios for sound production. Jack Warner became the head of production and remained at Warner Bros. until the late 1960s. Although he was known for being a hard-nosed businessman, Jack Warner oversaw some of the most successful Warner Bros. films, including *The Public Enemy* (1931), *Meet John Doe* (1941), *High Sierra* (1941), *Casablanca* (1942), *Strangers on a Train* (1951), *Rebel Without a Cause* (1955), and *Giant* (1956). Throughout the early 1970s, Jack Warner worked as an independent producer for the company.

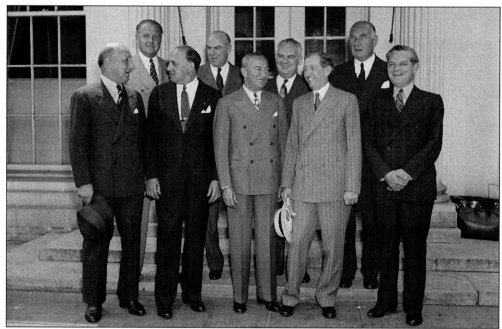

Albert Warner (second row, far right) joined a group of fellow executives at a conference with Pres. Franklin D. Roosevelt on June 25, 1938, to discuss the willingness of the film industry to work with the government. Other executives pictured include Barney Balaban (Paramount), Harry Cohn (Columbia Pictures), Nicholas M. Schenck (Loew's), Will Hays (MPPDA), Leo Spitz (RKO), Sidney R. Kent (20th Century Fox), and N.J. Blumberg (Universal). (Library of Congress.)

The Warner Bros. Administration Building is shown on this 1940s postcard photographed by Paul Adrian. During the 1940s, Warner Bros. churned out a prolific amount of classic, legendary films, including *The Maltese Falcon* (1941), *Yankee Doodle Dandy* (1942), and *The Treasure of the Sierra Madre* (1948).

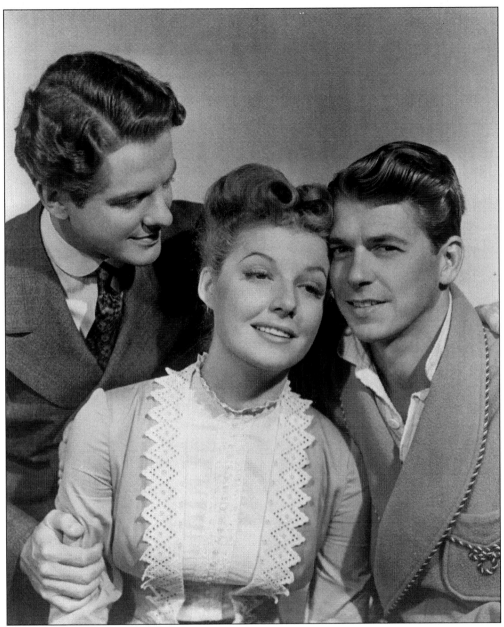

Pictured in this publicity photograph for the Warner Bros. drama *Kings Row* (1942) are Robert Cummings (left), Ann Sheridan (center), and Ronald Reagan. In 1937, Warner Bros. signed Reagan to a seven-year contract that netted him $200 per week. Reagan said that *Kings Row* was the movie that lifted him to "star status." The film, based on the best-selling novel by Henry Bellamann, received three Oscar nominations—for Best Picture, Best Director, and Best Cinematography.

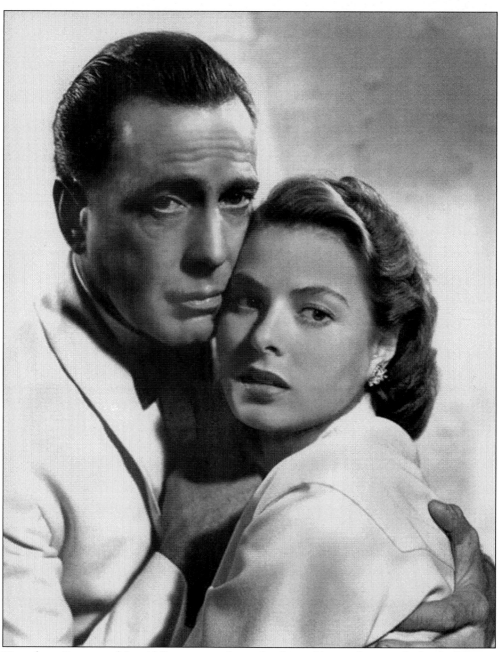

Humphrey Bogart and Ingrid Bergman embrace for this publicity photograph for the Warner Bros. movie *Casablanca* (1942). The classic film won three Oscars: Best Picture, Best Director (Michael Curtiz), and Best Screenplay (Julius J. Epstein, Philip G. Epstein, and Howard Koch). The on-screen chemistry of Bogart, as Rick Blaine, and Bergman, as Ilsa Lund, was undeniable. The film became one of 1942's highest-grossing movies and is widely considered one of the finest ever made.

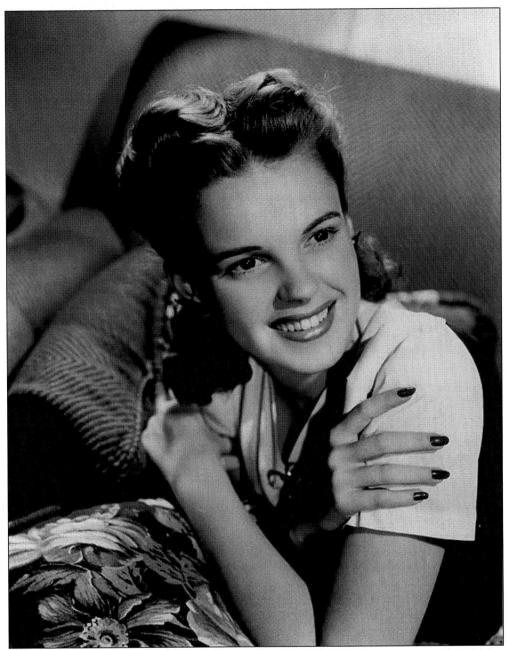

Judy Garland (1922–1969) poses in this vintage headshot. After signing a contract with MGM in 1935, Garland starred in *The Wizard of Oz* (1939), for which she won a special Academy Award for Outstanding Performance by a Juvenile Actress. Mickey Rooney presented Garland with her mini-statuette, which she affectionately dubbed the "Munchkin Award." Upon Rooney's request, Garland sang a rendition of "Over the Rainbow," the Academy Award–winning song by Harold Arlen and E.Y. Harburg. The film also won an Academy Award for Best Original Score (which was created by Herbert Stothart). After Garland left MGM, where she worked for many years, she starred in the Warner Bros. film *A Star is Born* (1954), winning a Golden Globe and earning an Academy Award nomination for her role.

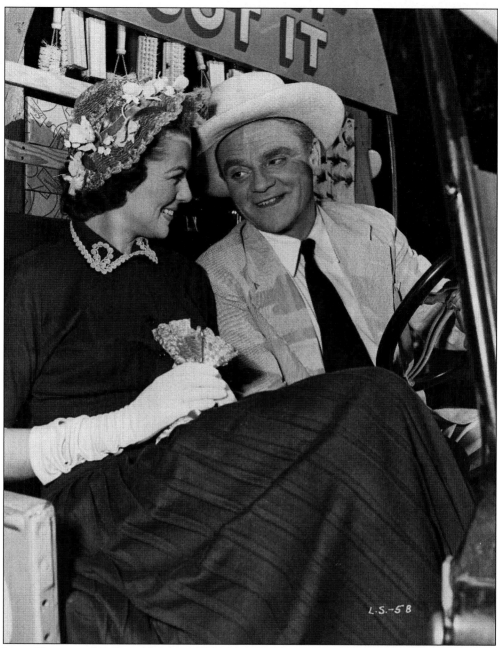

James Cagney and Barbara Hale starred in the 1953 Warner Bros. release *A Lion Is in the Streets*, based on the 1945 best-selling novel by Adria Locke Langley. Cagney played the role of Southern politician Hank Martin, while Hale played schoolteacher Verity Wade. The film, directed by Raoul Walsh and penned by Luther Davis, included three other Cagneys—James's sister, Jeanne, played a supporting role, while his brothers William and Edward worked behind the scenes (William produced and Edward served as story editor). James Cagney, who came to work for Warner Bros. in 1930, was a vaudeville and Broadway performer for many years. He was one of the first generation of actors to star in Hollywood "talkies." After signing a contract with Warner Bros., James Cagney acted in 38 films for the studio between 1930 and 1941.

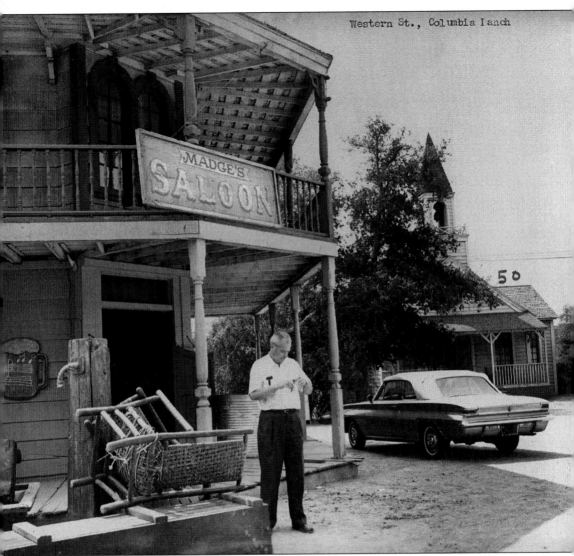

In 1934, Columbia Pictures purchased 40 acres at Hollywood Way and Oak Street. The site, called Columbia Ranch, provided the company with ample room to build exterior sets. The Western Street shown in this photograph was one of many sets built on the lot. Columbia Ranch's Western sets were notable settings for movies such as *The Lone Hand Texan* (1947), *High Noon* (1952), and *Cat Ballou* (1965). The Western set-up included two streets, complete with a general store, a courthouse, a train depot, railroad tracks, a church, a bank, a blacksmith, saloons, hotels, and a Mexican plaza. (BHS.)

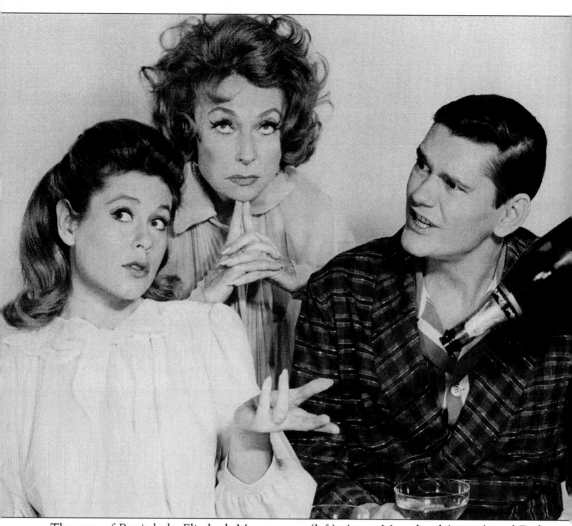

The stars of *Bewitched*—Elizabeth Montgomery (left), Agnes Moorehead (center), and Dick York—pose in this "magical" 1960s publicity photograph. When television emerged in the early 1950s, Columbia, known for movies, began to produce television series via Screen Gems, its television entity started by Ralph Cohn. During the 1960s, Screen Gems was known as the "House of Comedy" for its half-hour sitcoms like *Gidget, Hazel,* and *Bewitched.* The houses on Columbia Ranch's Blondie Street made many appearances on *Bewitched.* The house used for *Our Man Higgins* doubled as Darrin and Samantha Stephens's house. *Bewitched,* created by Sol Saks, aired from 1964 to 1972.

*I Dream of Jeannie*, created by Sidney Sheldon, aired on NBC from 1965 to 1970 as part of Screen Gems' lineup. Barbara Eden starred as Jeannie, while Larry Hagman played her "master," Maj. Anthony Nelson. The series filmed scenes at Columbia Ranch, with the Blondie Home, used in Columbia's serial *Blondie*, serving as Major Nelson and Jeannie's residence.

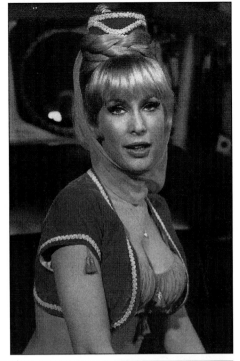

The Monkees—from left to right, Davy Jones, Michael Nesmith, Micky Dolenz, and Peter Tork—starred in their own Screen Gems sitcom, which aired on NBC from 1966 to 1968. Many of the show's scenes were shot at Columbia Ranch. Some set locations included the Western Streets and the Little Egbert House on Blondie Street.

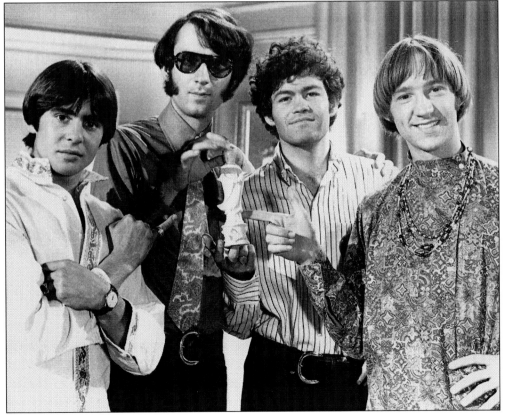

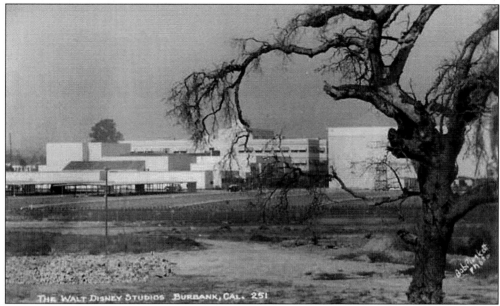

In 1939, the Walt Disney Studios relocated from Los Angeles to a 51-acre site in Burbank at Riverside Drive and Buena Vista Street. After the success of *Snow White and the Seven Dwarfs*, Disney needed to expand the company and found ample space in Burbank, as shown in this vintage postcard. (WC,MM/Burbankia; photograph by Bob Plunkett.)

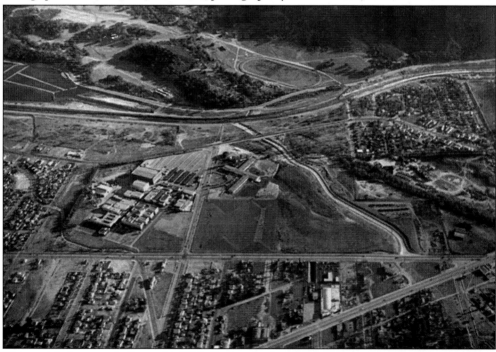

This aerial photograph shows the Walt Disney Studios (left) in the 1940s. Buena Vista Street and Alameda Avenue are visible along the outskirts of the studio. With the addition of the Walt Disney Studios, Burbank now had more than one major entertainment industry within its city limits. Others, such as NBC, would soon follow. (WC,MM/Burbankia.)

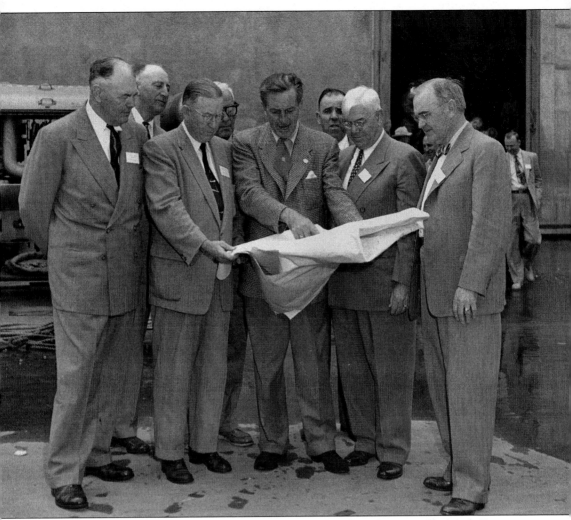

In this December 1954 photograph, Walt Disney discusses his plans for Disneyland with Orange County officials at the Walt Disney Studios. The men in the first row are, from left to right, Anaheim mayor Charles Pearson, Orange County supervisor Willis Warner, Walt Disney, supervisor Willard Smith, and Orange County Planning Commission chairman Dr. W.L. Bigham. Disney initially considered building Disneyland in Burbank on an eight-acre plot off Riverside Drive, near the Walt Disney Studios. The site is now home to the Walt Disney Feature Animation Building. Eventually, Disney decided he needed more space for his park and chose a 160-acre plot in Anaheim. (Orange County Archives.)

After Walt Disney saw Hayley Mills star in the British film *Tiger Bay* (1959), he signed her to a contract. Mills's lead role in *Pollyanna* (1960) marked her US film debut. In 1961, Mills played a dual role as long-lost identical twins in *The Parent Trap*. Mills also starred in other live-action Disney films, including *That Darn Cat!* (1965), *In Search of the Castaways* (1962), and *Summer Magic* (1963).

Julie Andrews won an Academy Award for Best Actress for her role in Disney's *Mary Poppins* (1964). Andrews, who had a prolific career on Broadway, caught the eye of Walt Disney, who cast her in the lead role. The film, based upon the children's book by P.L. Travers, merged live-action and animation and won an Academy Award for Special Visual Effects.

German architect Kem Weber designed the Walt Disney Studios casting building in 1938. The casting building was erected around 1939 and was the first building on the lot. It was initially used as a design studio, then as a warehouse. In the late 1950s, it was turned into offices, after which it served as the casting building. (Library of Congress.)

Kem Weber also designed the Process Laboratory, built in 1940, where the special effects department created Disney's live-action and animated movies. Under Walt Disney's direction, the special effects department developed a variety of techniques, such as surrounding an animator's hand-drawn figures with rivers, waterfalls, falling trees, fire, and shadows. This is a production room in the laboratory. (Library of Congress.)

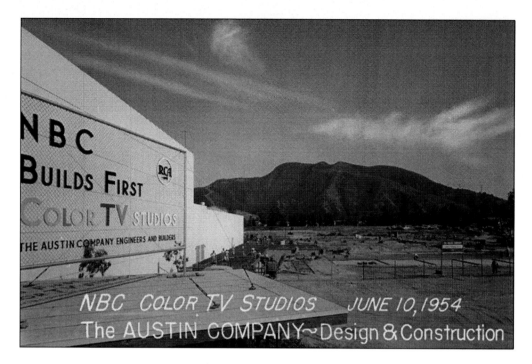

In addition to its television studios, which opened in 1952 at Olive and Alameda Avenues, NBC, with the help of the Austin Company, expanded by constructing an adjacent facility designed solely for color broadcasts. In these two 1954 postcards, history is being made as NBC becomes the first to build color studios from the ground up. In 1955, NBC opened its multimillion-dollar Color City, putting Burbank on the map as a television hub. (Both, WC,MM/Burbankia.)

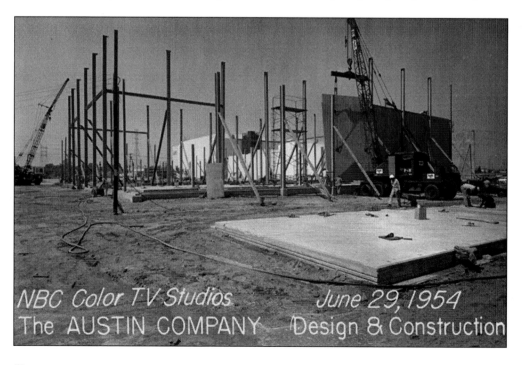

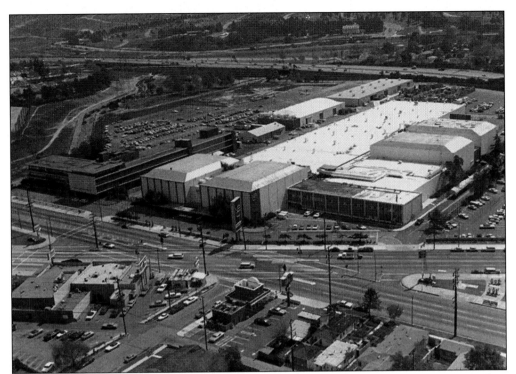

This aerial photograph shows NBC studios at the intersection of Olive and Alameda Avenues. When NBC's color studios were dedicated in 1955, the studio aired the television special *Entertainment 1955*, the first color telecast from the West Coast. By 1959, NBC aired the first color television Western series, *Bonanza*. (WC,MM/Burbankia.)

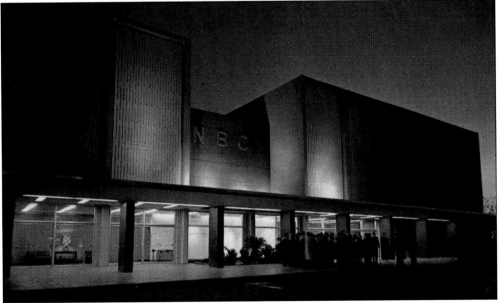

NBC's color television studios are illuminated at nightfall in this vintage postcard. By 1979, NBC studio tours and shows attracted millions of tourists each year. (Mitock & Sons; photograph by Frank Thomas.)

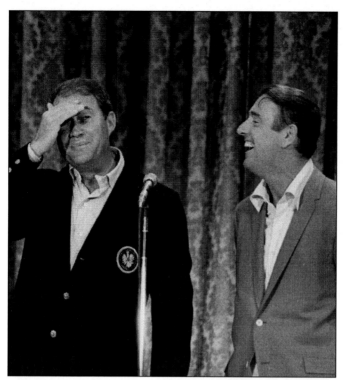

Dan Rowan (left) and Dick Martin, stars of *Rowan & Martin's Laugh-In*, share a laugh in this 1960s promotional photograph. Their sketch-comedy show aired its first season in 1968 and broadcast from Burbank's NBC studios until 1973. Gary Owens, the show's announcer, coined the phrase "Beautiful Downtown Burbank™," which gave the city worldwide recognition. In September 1969, nearly 400 people watched the show's publicity sketch at the downtown mall. Burbank mayor George Haven posed as "Lord Mayor" and crowned Rowan king of "Beautiful Downtown Burbank™" and Martin "first lady."

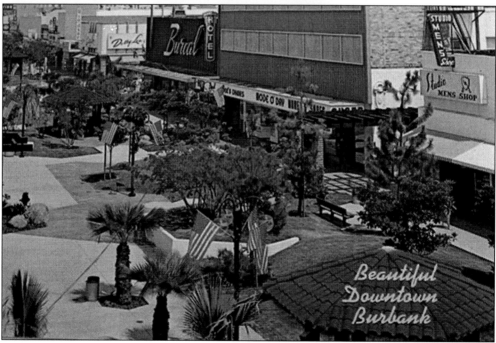

The charming setting of "Beautiful Downtown Burbank™" is featured in this vintage postcard showing the Golden Mall. In addition to appearing on an array of postcards, the phrase also made appearances on bumper stickers: "Vacation in Beautiful Downtown Burbank." Cars as far away as Scotland and Germany sported the slogan. (WC,MM/Burbankia.)

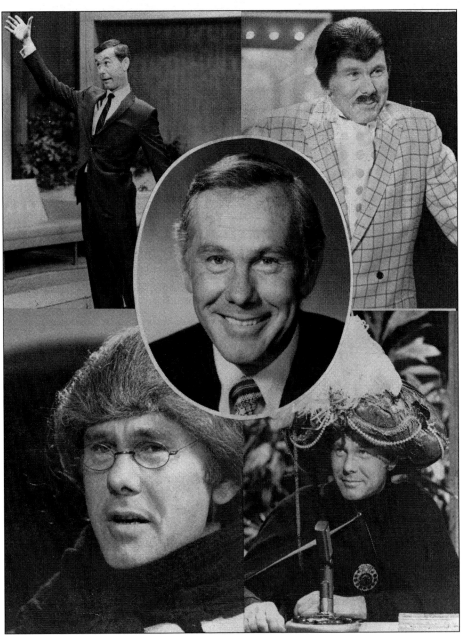

The many faces of Johnny Carson come to life in this 1977 publicity image. *The Tonight Show Starring Johnny Carson* moved from New York to Burbank in 1972. Burbank's NBC studios, which were suited for television, provided prop shops, scenery, and large stages, in contrast to New York's Rockefeller Center, which was built mainly for radio. Burbank's location also gave Carson access to Hollywood stars who could appear on his show. Carson brought many memorable characters to late-night television, including Art Fern (top right), the host of "Tea-Time Movie;" Carnac the Magnificent (bottom right), "The Mystic from the East;" and elderly Aunt Blabby (bottom left). Carson (1925–2005) taped his Emmy-winning show in Burbank from 1972 until 1992. Some of Carson's honors include a Peabody Award, the Presidential Medal of Freedom, and the Kennedy Center Lifetime Achievement Award.

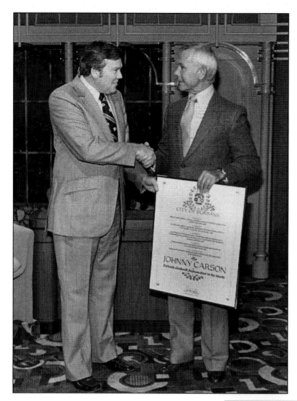

In the image at left, Johnny Carson accepts an award from Burbank mayor Leland C. Ayers to become Burbank's ambassador. Below, Tom Snyder (left) sits with guest Orson Welles on NBC's late-night talk show *Tomorrow* in this press photograph from April 8, 1975. Snyder's program, which aired after *The Tonight Show Starring Johnny Carson*, taped in Burbank and shared a soundstage with *The Tonight Show* until November 29, 1974. Snyder (1936–2007) then moved to New York to tape the rest of his series. (Left, WC,MM/Burbankia.)

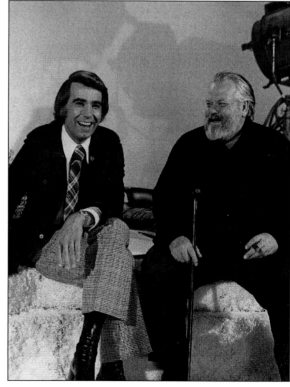

# *Three*

# COME FLY WITH ME

"I expect to see the time when aviation will be the safest means of transportation," said Allan Loughead in the early 1900s, adding that the airplane will "take over land and water travel—flying has no barriers." Neither did his vision to become an aviator. Loughead, a self-taught pilot and future general manager of the Lockheed Aircraft Company, built his first plane—the Model G—with his brother Malcolm. (Both brothers eventually changed the spelling of their last name to "Lockheed.") With Allan as pilot, the wood-and-fabric seaplane made its first flight in San Francisco on June 15, 1913. It swirled above Alcatraz, Nob Hill, and Market Street—the first Lockheed airplane to cruise the skies.

By 1916, the Loughead (later changed to Lockheed) Aircraft Manufacturing Company opened in Santa Barbara, where Allan and Malcolm, with draftsman John K. Northrop, began to work on their latest plane, the triple–tail finned F-1. Ten years later, the Lockheed Aircraft Company moved its headquarters to Hollywood. Here, Allan and Northrop (now hired as an engineer) built the famed Vega. Lockheed made headlines when George Hearst bought the company's first Vega—the *Golden Eagle*. Lockheed's fame was amplified in 1928, when George Hubert Wilkins and Ben Eielson flew Vegas over both the North and South Poles. Vega orders soon inundated the small Hollywood factory. Needing to expand, Lockheed moved its facilities in 1928 to a 20,000-square-foot Burbank factory at San Fernando Boulevard and Empire Avenue.

United Airport, the first million-dollar airport in the United States, opened in 1930 (and was renamed Union Air Terminal in 1934). This garnered more aviation attention for Burbank and attracted famed pilots such as Paul Mantz, James Wedell, and Roscoe Turner. In 1940, Lockheed bought Union Air Terminal and renamed it Lockheed Air Terminal (now the Bob Hope Airport).

From famous aviators such as Amelia Earhart and Wiley Post breaking records in Lockheed planes to the company's prolific production of P-38s, B-17s, and Hudson bombers during World War II, Lockheed's name became inextricably connected to Burbank.

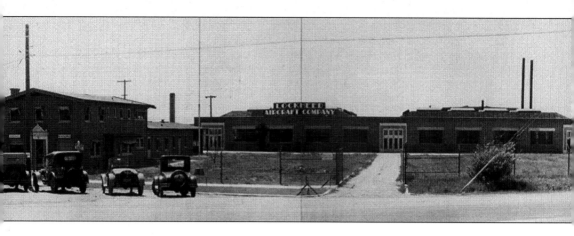

The Lockheed Aircraft Company was established in 1926 with an investment from Allan Lockheed and Fred S. Keeler, stockholder in the Empire China Company. Allan Lockheed became general manager and vice president, while Keeler served as president. First operating out of a small Hollywood garage at Sycamore and Romaine Streets, the company then expanded and moved its headquarters to Burbank in 1928. Below, Lockheed workers gather for a group photograph; the kilns from the neighboring Empire China Company are visible in the background at left. (Both, WC,MM/Burbankia.)

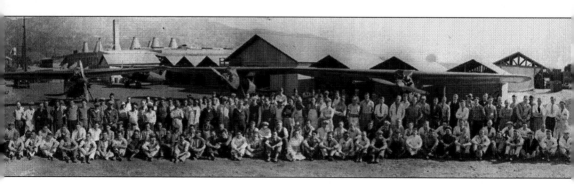

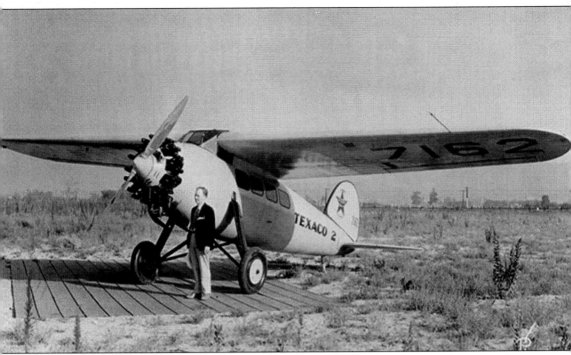

Allan Lockheed (1889–1969) stands next to a Lockheed Vega (NC-7162) in this c. 1928 photograph. Following the success of the Vega, the company began using the slogan "It takes a Lockheed to beat a Lockheed." Pilots like Amelia Earhart, Wiley Post, and Bobbi Trout were breaking records in Vegas, all of which bore the famous name—Lockheed. (WC,MM/Burbankia.)

Amelia Earhart, outfitted in her leather jacket, stands next to her Lockheed Vega 5C (NR-965Y), which she flew from Hawaii to California in January 1935, making her the first woman to complete this journey. Earhart also enjoyed great success in a Vega when she became the first woman to fly solo across the Atlantic Ocean in 1932. (WC,MM/Burbankia.)

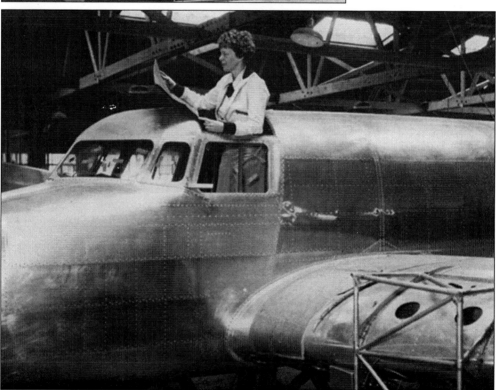

Amelia Earhart stands inside the cockpit of her Model 10-E Electra at Lockheed in this c. 1936 image. The Purdue Research Foundation purchased the plane for $80,000; Earhart called it her "flying laboratory." Lockheed customized the 10-E with specialized navigation equipment and 12 fuel tanks, including six on the wings. Although Earhart broke records in Lockheed's Vega, her 10-E Electra had a devastating fate—she (and the plane) disappeared over the Pacific Ocean on July 2, 1937, during her attempt to fly around the world. (WC,MM/Burbankia.)

Laura Ingalls (1901–1967) set aviation records in Lockheed's Air Express, a revamped, faster version of the Vega. In 1934, she was the first to fly solo in her Air Express from North to South America, a trek of nearly 17,000 miles. In September 1935, Ingalls set the nonstop transcontinental speed record for women when she flew her Lockheed Orion from Burbank to New York in just over 13.5 hours. (WC,MM/Burbankia.)

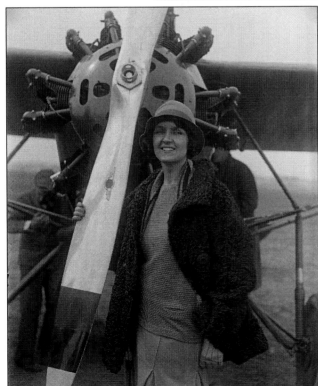

Ruth Nichols (1901–1960) found luck in a Lockheed Vega. In 1930, she was the first woman to make a transcontinental flight from New York to Burbank; it took 16 hours, 59 minutes, and 30 seconds. In 1932, Nichols set an altitude record—flying at 19,928 feet—for a diesel-powered plane in her Vega, nicknamed the "Flying Furnace." (Library of Congress.)

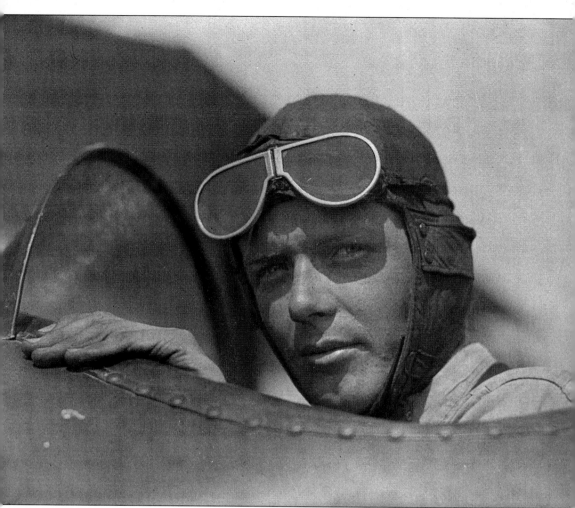

"There were times in an aeroplane when it seemed I had escaped mortality to look down on earth like a God," said Charles A. Lindbergh (1902–1974), also known as "Lucky Lindy," famous for making the first solo transatlantic flight from New York to Paris in May 1927. He completed a bevy of record and survey flights in a Lockheed Sirius. Lindbergh's Sirius, painted black and crimson, was dubbed *Tingmissartoq*, an Eskimo word meaning "one who flies like a big bird." On April 20, 1930, Lindbergh and his wife, Anne Morrow (1906–2001), flew from Glendale to New York in just under 15 hours. After the Lindberghs embarked on a worldwide trip from Washington, DC, to Tokyo Bay in 1931, the Sirius was revamped with a 710-horsepower engine for the Lindberghs' 1933 survey flight of 29,000 miles from New York through the North and South Atlantic Ocean. (Library of Congress.)

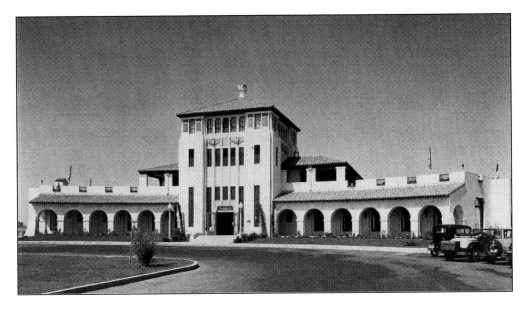

With Lockheed thriving, the city welcomed another aviation giant. In 1930, the beautiful Spanish-style United Air Terminal opened at the city's new United Airport. Construction on the $1.5-million airport began in 1929, when United Aircraft and Transport Corporation purchased 240 acres of land on the corner of Vanowen Street and Hollywood Way. The City of Burbank donated a portion of Winona Street for runways. United Airport opened on Memorial Day in 1930 with a dedication ceremony (below) and a three-day celebration including a city parade and a flight show with Boeing P-12 pursuits and Keystone bombers. Thousands of spectators enjoyed the gala, including elite Hollywood stars. (Above, GoDickson.com/AHSFV; below, WC,MM/Burbankia.)

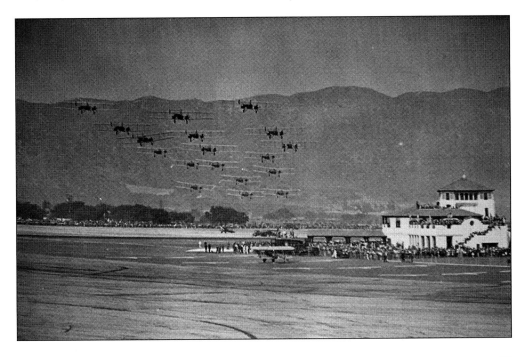

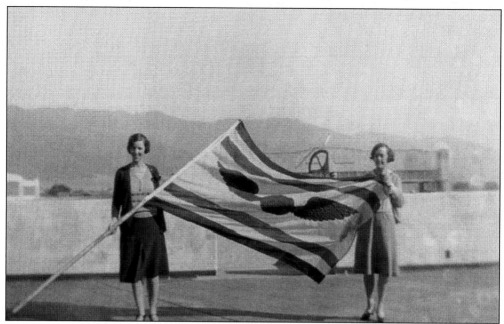

Katherine Smith (right) and an unidentified companion wave the first airmail flag at United Airport. On November 17, 1929, the first airmail flight departed from United Airport carrying 5,300 letters—344 pounds of mail. Smith, who came to work at United Airport in 1930 for Tom Hamilton and the Hamilton Aero Manufacturing Company, worked the switchboard, signaled planes for landing, learned to fly from famous stunt pilot Paul Mantz, and befriended Amelia Earhart, who gave her motorcycle rides around United Airport. In the photograph below, snow covers United Air Terminal. Within one month, Burbank was blasted with two heavy snowstorms—one on December 14, 1931, and another on January 15, 1932. (Both, Katherine Smith/GoDickson.com.)

Hangar 14 is pictured at United Airport in the early 1930s. Built by the Austin Company for Tom Hamilton and the Hamilton Aero Manufacturing Company, the hangar was located at Hollywood Way and Winona Avenue. While working in Hangar 14, aviator Katherine Smith helped prepare Anne and Charles Lindbergh's office and often had to close the windows so onlookers would not disrupt them as they worked on their Lockheed Sirius. (GoDickson.com/AHSFV.)

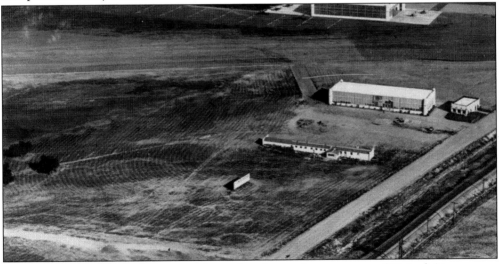

The Northrop Aircraft Corporation, located at the southwest corner of United Airport, was founded by famed aircraft designer John "Jack" K. Northrop. In the early 1930s, it became one of the first corporations to move into United Airport. One of the company's many accomplishments was creating the Northrop Gamma, an all-metal aircraft. (GoDickson.com/AHSFV.)

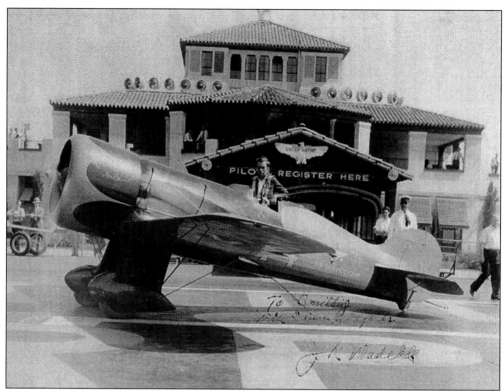

This early-1930s photograph, autographed by prizewinning air racer James Wedell (1900–1934), shows Wedell at United Airport with his specially built aircraft. After forming Wedell-Williams Air Service Corporation in the late 1920s, Wedell went on to design a line of famous Model 44 racers. (Katherine Smith/GoDickson.com.)

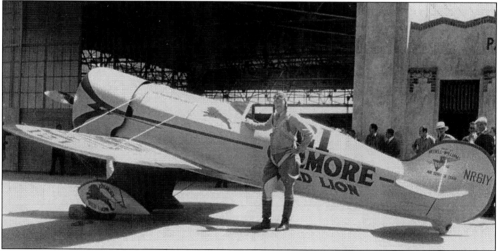

Air racer Roscoe Turner (1895–1970) poses next to his Wedell-Williams Model 44 racer (NR61Y) in front of Hangar One at United Airport in the early 1930s. Turner's plane, designed by James Wedell, was dubbed the *Gilmore Red Lion* after Turner's sponsor, the Gilmore Oil Company, and Turner's pet lion, Gilmore, who often flew with him and even had his own parachute in case of an emergency exit. (Katherine Smith/GoDickson.com.)

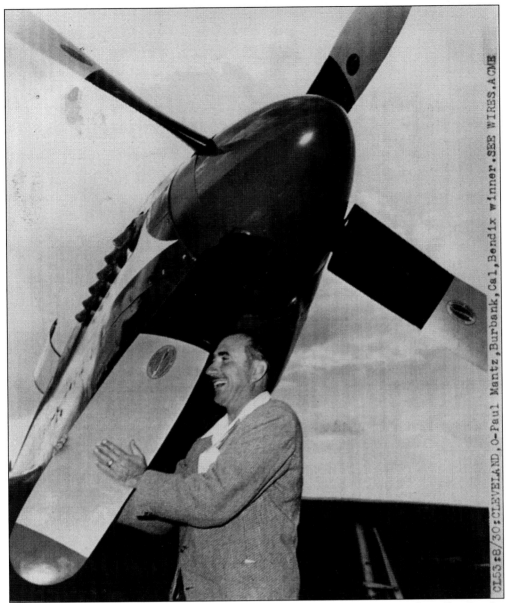

Famed air racer Paul Mantz (1903–1965) celebrates as he embraces the propeller of his Bendix Trophy winner in this 1947 press photograph taken in Burbank. This was Mantz's second Bendix win; he won three consecutive Bendix races in a row (from 1946 to 1948). In the early 1930s, Mantz started his own company, United Air Services, at United Airport, where he supplied studios with planes and stunt pilots for their films. Mantz also headed an air charter service and flew the "Honeymoon Express," which attracted many Hollywood stars looking for a quick Las Vegas wedding or divorce. Mantz, also an affluent movie stunt pilot, worked on films including *Air Mail* (1932), *Men with Wings* (1938), *Blaze of Noon* (1947), *Gallant Journey* (1946), and *The Spirit of St. Louis* (1957). Unfortunately, his career came to an end when he died in a crash while filming *The Flight of the Phoenix* in 1965. (Acme Photograph.)

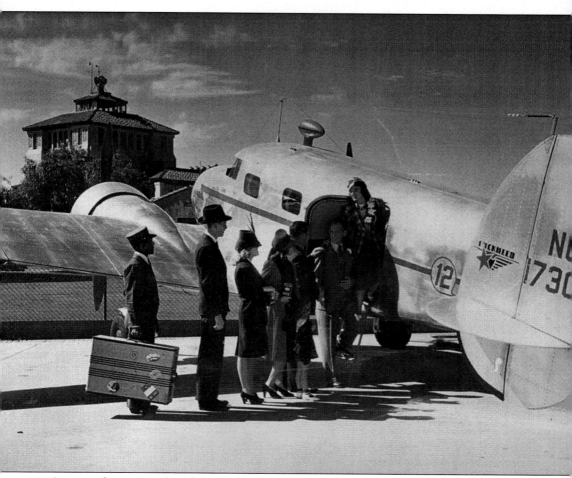

A group of passengers board the Lockheed Model 12 in this late-1930s photograph. Dubbed the Electra Junior, the Model 12 was a pint-sized spin-off of the Model 10 Electra and was used as a feeder airliner. The all-metal aircraft carried six passengers and two pilots and had a maximum speed of 225 miles per hour at an altitude of 5,000 feet. It made its first flight at 12:12 p.m. on June 27, 1936, a time specifically selected to match the plane's model number. The Model 12 made several appearances on the big screen, including in *Casablanca* (1942), *State of the Union* (1948), and *Amelia* (2009). (Daniel MacPherson.)

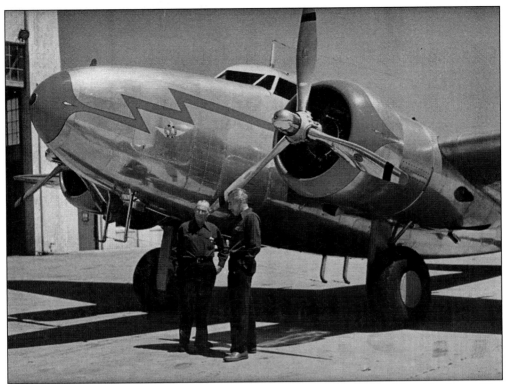

In this image from the late 1930s, two employees stand in front of a Lockheed Lodestar. The Lodestar would make its mark as a transport plane during World War II. (Daniel MacPherson.)

In 1940, Lockheed Aircraft Corporation purchased Union Air Terminal and renamed it Lockheed Air Terminal, as shown on this map. Shortly after, in 1941, the United States entered World War II, and Lockheed played a prominent role in wartime plane production. (Daniel MacPherson.)

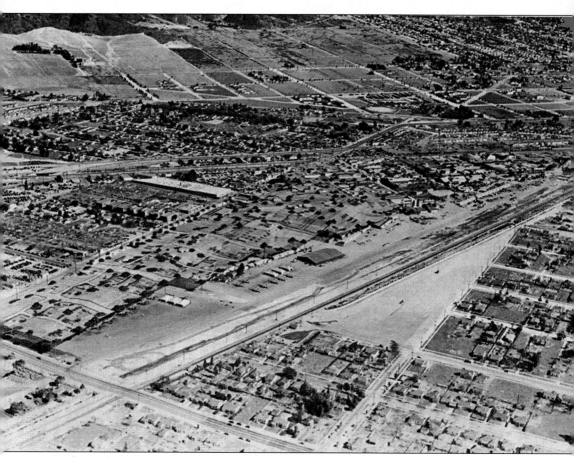

In this early-1940s aerial photograph, the Lockheed Air Terminal, Lockheed plants, and Vega plants are camouflaged as a farmland scene during World War II. With the help of artists and set designers from studios such as Disney, the booming aircraft industry was disguised as a calm farming community in an effort to divert possible enemy attacks. The landscape was complete with grain and alfalfa fields, farmhouses, and trees. Chicken wire, chicken feathers, netting, and canvas were also used to disguise the facilities. Parking lots were turned into alfalfa fields, telephone poles were transformed into treetops, and fake cars were repositioned on faux streets. Employees went along with the ruse, often hanging and removing laundry from clotheslines near burlap bungalows during their breaks. (WC,MM/Burbankia.)

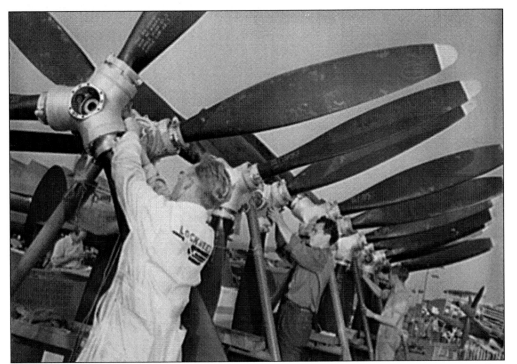

In the July 1942 photograph above, Lockheed employees ready three-blade variable-pitch propellers to be installed on Lockheed P-38 pursuit planes. Pursuit planes, used to escort bombers, would intercept attacking enemy planes. Used mainly in the Pacific theater during World War II, the P-38s also served as dive bombers and reconnaissance planes. Below, construction continues on P-38 pursuit planes at Lockheed in July 1942. With the wings and Allison engines intact, these planes are near the stage when propellers will be attached. (Both, Library of Congress.)

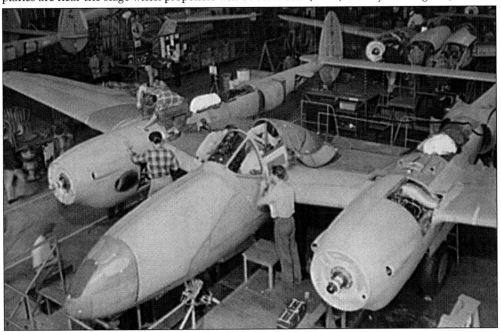

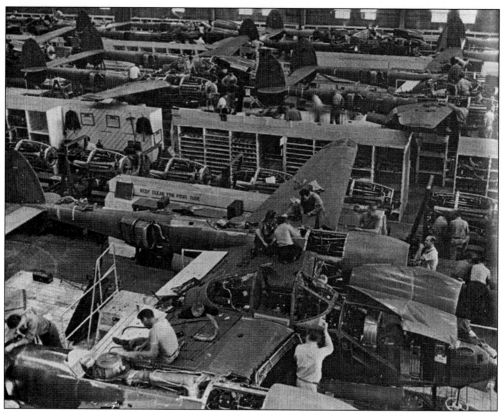

In 1944, P-38 production thrived at Lockheed. That year, 4,186 P-38s were delivered toward the World War II effort, nearly doubling its 2,497 deliveries in 1943. The P-38's capability of flying at low altitudes for long distances made it a successful combat plane in the South Pacific. In 1943, a P-38 Lightning shot down Adm. Isoroku Yamamoto, commander of the Japanese Navy and architect of the attack on Pearl Harbor. Below, a completed P-38 pursuit plane sits outside the Lockheed Air Terminal in November 1942. (Above, WC, MM/Burbankia; below, Library of Congress.)

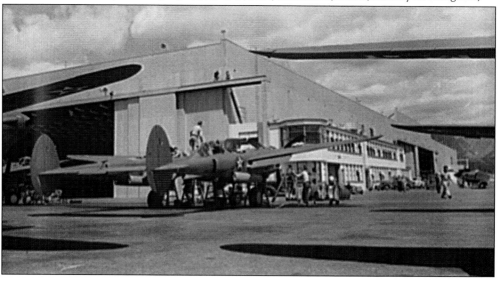

Perk H. White, son of Earl Loy White (founder of KELW, Burbank's first radio station) and Anna White, was a World War II veteran who served in the Navy on submarine patrol boats. Before entering the war, he worked at Lockheed on P-38 Lightning fighters and helped design the twin-seat and photographic versions. (Lansing White.)

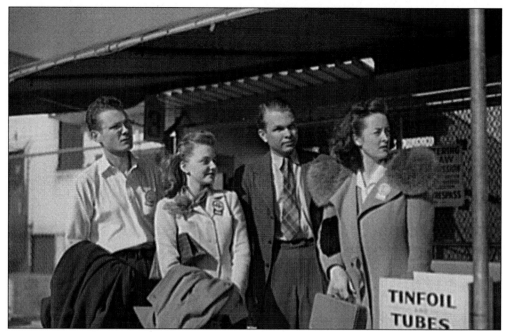

In this June 1942 photograph, a group of Lockheed Vega employees gathers for a carpool in an effort to conserve tires during World War II rationing. Among the employees are a shop worker, a female factory worker, a production controller, and a stenographer. The average commute for a Lockheed Vega employee was approximately 10 miles. (Library of Congress.)

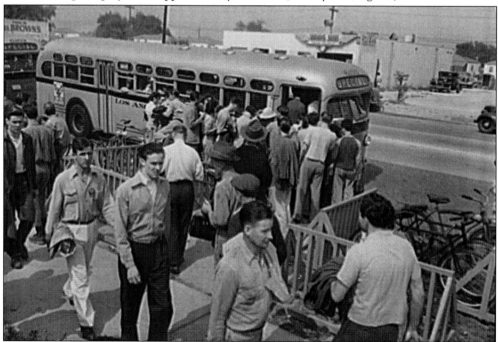

Besides the carpooling system, buses provided by the Lockheed Vega Corporation aided in tire and gasoline rationing. The employees who needed to commute to work took advantage of the company's 84 buses that serviced all of the Lockheed Vega gates in June 1942. (Library of Congress.)

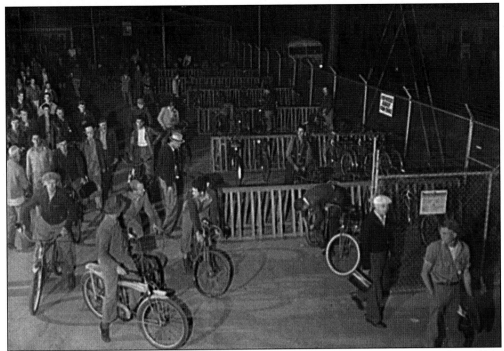

Bicycles also helped people to conserve rubber and gasoline during wartime. Bicycles, sold at discounted prices by Lockheed Vega, allowed employees who lived within four miles of the company to use alternate transportation. Employees could sell the bicycles back to Lockheed Vega when they no longer needed them. This June 1942 photograph shows employees heading home after a swing shift at 12:30 a.m. Below, Lockheed workers from Jack Tomlin's noon shift pose for a group photograph in 1943. (Above, Library of Congress; below, WC,MM/Burbankia.)

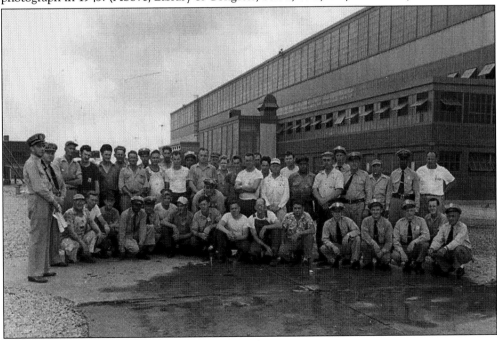

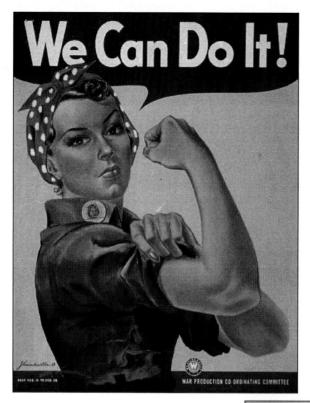

Women came to Lockheed's aid during World War II. This *We Can Do It!* poster, created by artist J. Howard Miller (1918–2004) for Westinghouse around 1942, was used to support and encourage female workers during the war. The image was inspired by a United Press photograph of Geraldine Hoff Doyle, a teenage Michigan steelworker. (National Archives.)

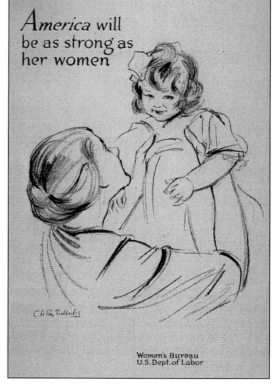

This World War II poster, titled *America Will Be as Strong as Her Women*, was created by artist Cyrus Leroy Baldridge (1889–1977). Baldridge was raised by a single mother who instilled in him a confidence and independence honored in this charcoal sketch for the Women's Bureau/US Department of Labor. (National Archives.)

Two women use riveting guns to precisely assemble a fuselage at the Lockheed factory during World War II. Many women were hired to work at Lockheed during wartime, and by June 1943, almost 35,000 women were employed there, making women nearly 40 percent of the company's total workforce. In an effort to support women in the workplace, the popular slogan and song "Rosie the Riveter" became popular across America. (WC,MM/Burbankia.)

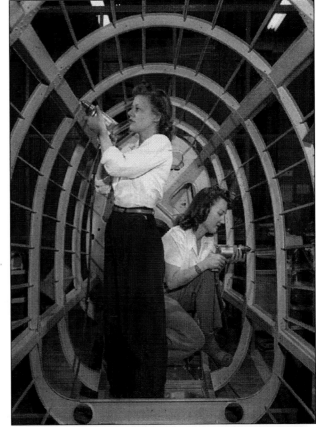

Flora Foss (left) worked as a lathe operator at the Lockheed Vega factory during World War II. In this image, she is being visited by her brother Joseph Jacob Foss, "America's Air Ace" of the US Marine Corps. (WC,MM/Burbankia.)

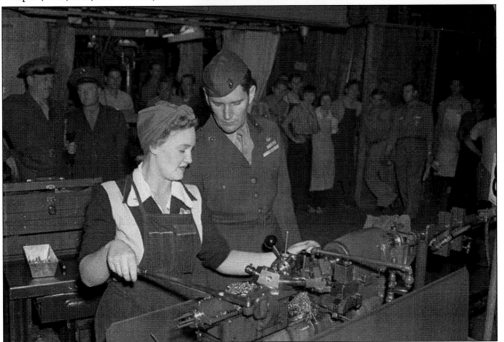

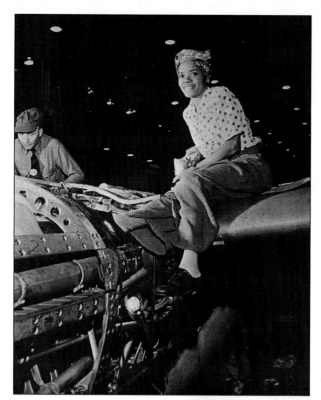

World War II altered women's wardrobes, especially in the workplace; the days of skirts and heels were over. In this 1940s photograph, an unidentified riveter sits atop the wing of a Lockheed aircraft as she prepares to rivet the plane's interior. Her pants, bandana, and safety shoes were common attire for female workers. Before 1943, metal-toed safety shoes did not even exist in women's sizes. (National Archives.)

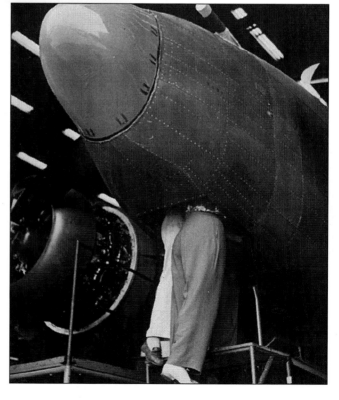

In this August 1943 photograph, two women at work are half-swallowed by a bombardier's hatch at the Vega aircraft plant. Women worked on prominent Lockheed aircraft during the war, including P-38s, Hudson bombers, and Boeing Flying Fortresses. (National Archives.)

A Vega Aircraft Corporation employee inspects electrical assemblies in June 1942. The electrical assembly department was one of the first in which women began to work. Prior to landing a job at Lockheed Vega, women were required to take an IQ test, a manual-dexterity exam, and a mechanical aptitude test. (Library of Congress.)

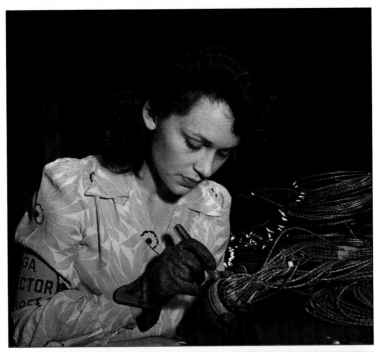

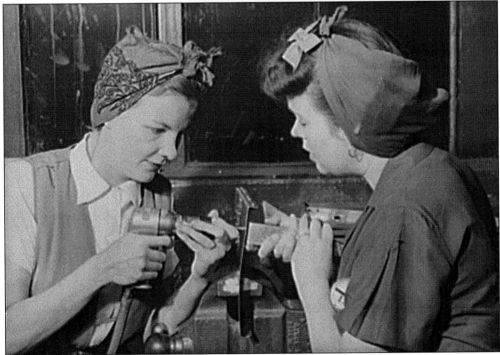

Fern Evans (left) and Evelyn J.W. Casola demonstrate the power of teamwork at Lockheed in this May 1942 image. They riveted radio parts to be used in bomber planes. Both Pearl Harbor widows learned technical jobs to help in the war effort. "We feel that we should do all we can to carry on the work and the cause for which our husbands so nobly gave their lives," said Evans in a 1942 issue of the *Evening Leader*. (Library of Congress.)

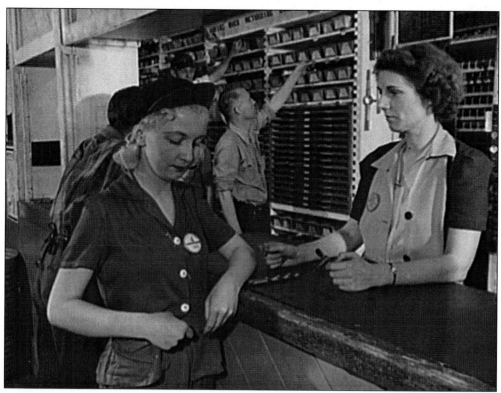

A tool crib keeper hands a drill to a Lockheed drill press operator in May 1942. According to a War Department news release from winter 1942–1943, a new female worker, when trained by a veteran male drill operator, could learn to run a small drill press in just one week. (Library of Congress.)

Four Lockheed Vega employees enjoy a lunch break in August 1943. Women from all walks of life—including beauty shop employees, dressmakers, and homemakers—worked as machinists, welders, and inspectors for the aviation industry. The Lockheed Vega Corporation offered training courses, counselors, and free access to a library in order to help women advance in their line of work. (National Archives.)

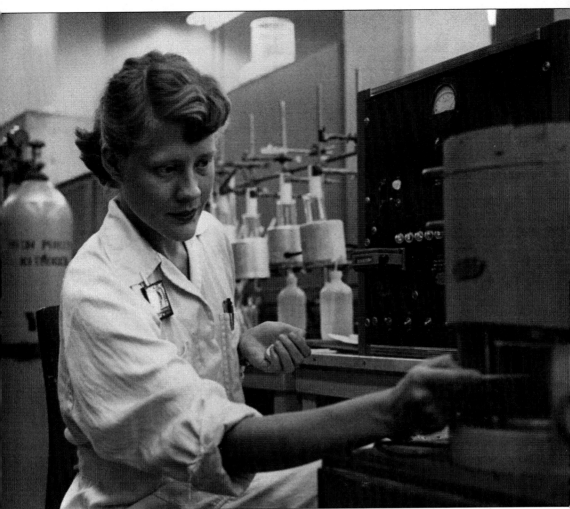

Women continued working after World War II. Jane Blankenship Gibson worked at Lockheed Aircraft Corporation as a spectroscopist in the early 1960s. With a bachelor of science degree in chemistry from the University of Tennessee, she was a well-educated role model for women in scientific fields. This 1961 photograph appeared in a news article urging women to enter the field because scientists would aid the United States during the Cold War. (Smithsonian Institution.)

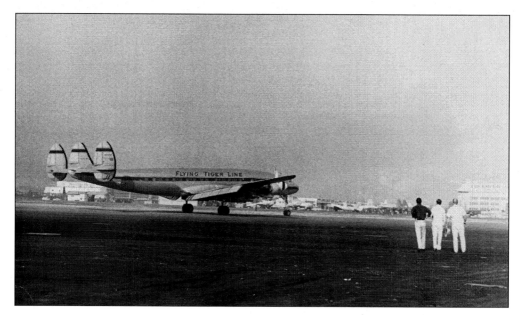

After World War II, 10 American Volunteer Group pilots—Robert Prescott, Duke Hedman, Link Laughlin, Cliff Groh, Bus Loane, Bill Bartling, Tommy Haywood, Joe Rosbert, Dick Rossi, and Catfish Raine—formed the Flying Tiger Line, an all-cargo company. These images show two of the Flying Tiger Line's Constellations at Lockheed Air Terminal. The idea for the transcontinental airfreight route began in 1944 with Prescott. While working with fellow World War II Flying Tigers veterans, Prescott raised nearly $90,000, which was matched by associates of Samuel B. Mosher (president of Signal Oil Company). Prescott started the company on June 25, 1945. With a motto of "Anything, Anytime, Anywhere," its first loads carried four tons of strawberries, grapes, and cantaloupes from Bakersfield, California, to New York. The company went on to deliver a wide variety of goods. (Both, the Flying Tigers Group/BAM.)

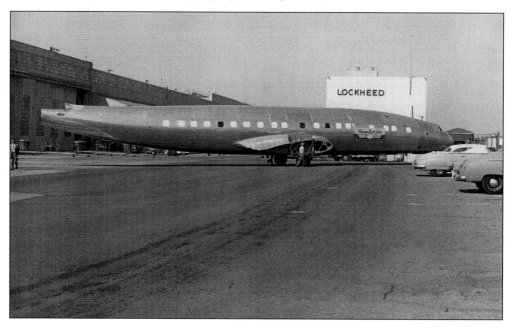

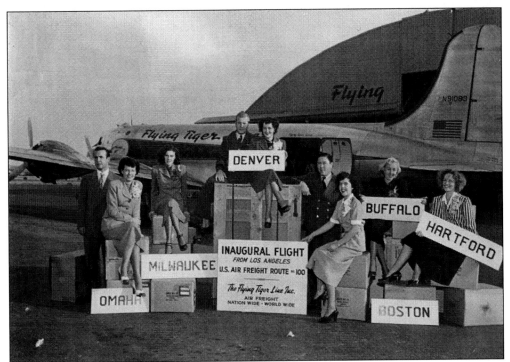

Personnel from the Flying Tiger Line sit among boxes of cargo in this 1949 image. That same year, the Flying Tiger Line received official government certification to become the first commercial all-cargo route in the nation. Below is the Flying Tiger Line's office, which opened in the 1950s on Clybourn Avenue and Sherman Way, just two blocks from Burbank's airport. (Both, GoDickson.com/AHSFV.)

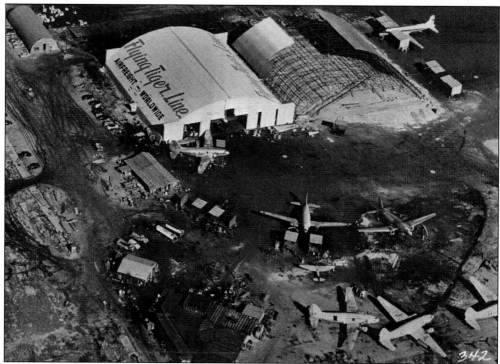

In this 1950s photograph, a second hangar is being constructed for the Flying Tiger Line at Lockheed Airport. Just a decade later, the company exponentially flourished and became an industry leader for all-cargo flights. By the end of the 1960s, the company increased its destinations and hauled more cargo thanks to use of jet freighters rather than propeller-driven, piston-engine planes. The company thrived until the late 1980s, when Federal Express bought it. Below is an aerial view of the Flying Tiger Line's two completed hangars. (Both, the Flying Tigers Group/BAM.)

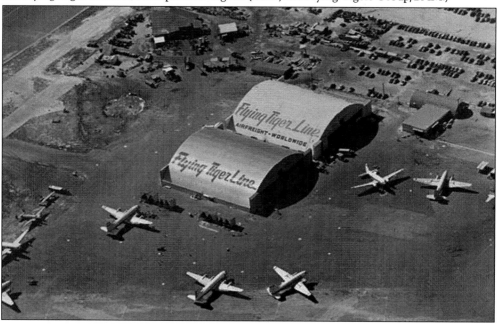

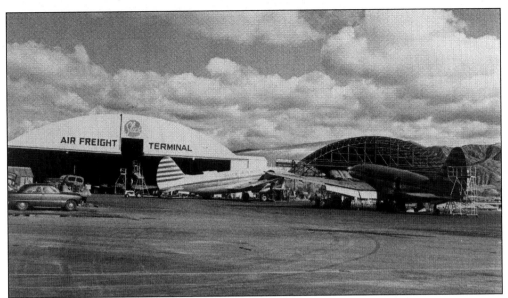

Slick Air Freight Terminal is shown here at Lockheed after World War II. According to Slick's president, Thomas L. Grace, as quoted in an article from the January 1952 *Burbank Daily Review*, 1951 proved to be Slick Airways' most prolific year in its five-year existence. The airline increased its fleet to 25, added new cities to its routes, and established contracts with the Navy and the Air Force. (GoDickson.com/AHSFV.)

Malcolm Graham Stratford (1918–1994) flew B-17s in North Africa during World War II, including 29 missions, six of which he served as aircraft commander for. After the war, he joined the Air Force Reserves and worked for TWA and, later, Slick Airways, until 1951, after which he served as a pilot in the Korean War. After the Korean War, he flew Lockheed Constellations and worked in Lockheed's Flight Test Engineering Division. He retired from the Air Force Reserves as a colonel in 1978. (Ceci Stratford.)

# *Lockheed Constellation*

**FAMED AIRLINES WILL FEATURE THEM**

This is the Lockheed Constellation—the largest, fastest, highest-
flying transport in use today. Efficient
and hard-working as an Army express, its career is just
beginning. Already many farseeing airlines including TWA,
Eastern Air Lines and National Airlines
have contracted for fleets of these majestic craft—are
prepared to offer you, when peace comes, the swiftest schedules
and most luxurious travel in the history of flight.

## LOOK TO LOCKHEED FOR LEADERSHIP

*Lockheed Aircraft Corporation, Burbank, California*

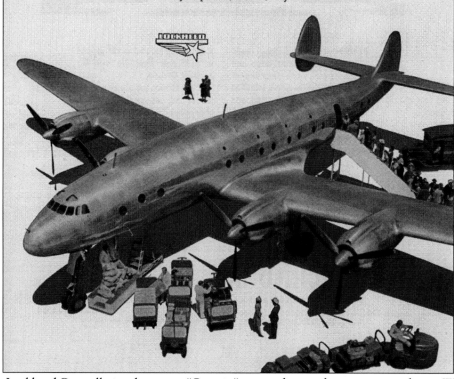

The Lockheed Constellation, known as "Connie," was used as a military transport during World War II. Afterwards, it made long-distance commercial flights; its first was on February 3, 1946. It was initially equipped with seats for 44 passengers, a pressurized cabin, and hydraulically assisted power controls—the first of its kind—and cruised at a speed of nearly 350 miles per hour. This 1945 advertisement touts the Connie as "the largest, fastest, highest-flying transport in use today."

# Four

# IN BLOOM

Decked in thousands of blooms, elegant, eye-catching floats grace Colorado Boulevard during the Pasadena Tournament of Roses Parade (also known as the Rose Parade)—a New Year's Day tradition since 1889. The City of Burbank entered its first float in the prestigious Rose Parade in 1914. The float was so well received that from 1915 to 1921, the Burbank Chamber of Commerce built four prizewinning floats for the city.

The city did not enter another float until 1935, when Burbank Public Schools took up the challenge to design, build, and decorate the floats under the direction of Alice DeHater, the head of the art department. Over the ensuing six years, each float garnered a prize, with two winning the Sweepstakes.

By 1941, the Burbank Junior Chamber of Commerce, under president Cecil Schilling, built the city's 12th float entry for the Rose Parade. Unfortunately, the float never had the chance to shine, because the 1942 Rose Parade was cancelled after the attack on Pearl Harbor on December 7, 1941. Changing their focus to wartime support efforts, the Burbank Junior Chamber of Commerce used the money set aside for the float to buy a truck that it used to deliver free coffee to local soldiers pulling night duty.

After the war, the City of Burbank hired Isabella Coleman to build and decorate its 1947 float. That same year, the Burbank Tournament of Roses Association (BTORA) was formed. A nonprofit organization driven by volunteers, BTORA crafts self-built floats and has entered a float in every Rose Parade since 1948. Today, Burbank is one of only six registered self-built float organizations that remain in the Rose Parade. Each year, hundreds of volunteers donate time, affixing flowers by hand to create a new Burbank beauty—a float rooted in community, tradition, and civic pride.

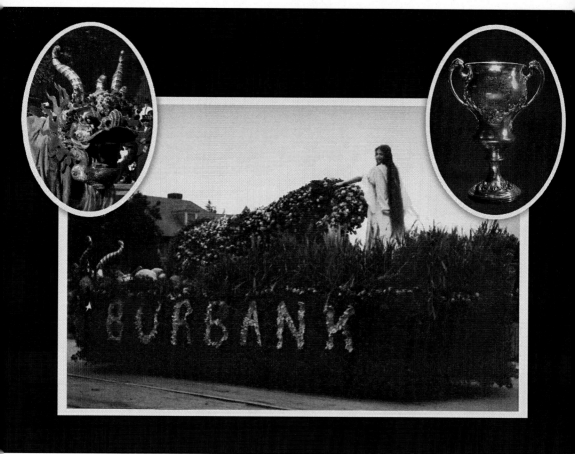

In 1914, "Goddess of Plenty" became Burbank's first float entry in the Pasadena Tournament of Roses Parade. The float was covered with homegrown fruits and vegetables donated by the community. Among an array of sweet potatoes, pumpkins, and squash stands Stella Hansen, a Burbank high school teacher and the city's first float rider. Hansen, who portrays the goddess Ops, did not plan to be in this famed position. A secret ballot was cast to determine the queen of the float, but the vote came to a tie between two candidates: Miss Ludlow and Miss Brotman, who each received 365 votes. In order to break the tie, the ladies graciously decided to choose Hansen for the honors even though she was not listed on the ballot. The upper left inset shows a close-up of the dragon's head that adorned the front of the float. In the upper right corner is the Special Prize Silver Cup Trophy for "Goddess of Plenty"—the *Los Angeles Tribune* awarded the trophy to the City of Burbank on January 1, 1914. (BTORA.)

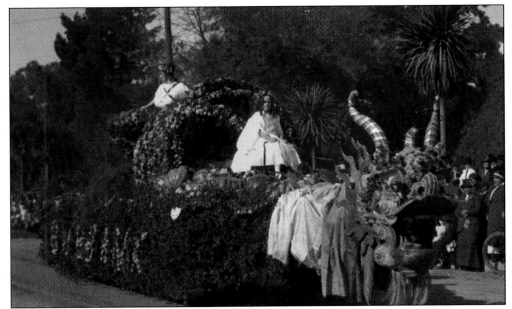

"Dragon Cornucopia" motored down the parade route in 1915 with two riders. A revamped version of "Goddess of Plenty," it featured the same elaborate dragon's head, which now pivoted from side to side, making it Burbank's first animated float. The Burbank Chamber of Commerce built the float with a $100 donation from the city, and the float won fourth prize. (BTORA.)

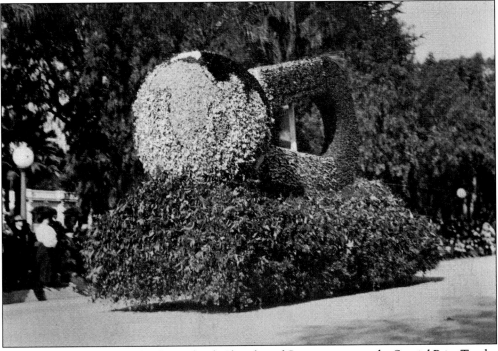

"Globe and Magnet," built by the Burbank Chamber of Commerce, won the Special Prize Trophy in 1921. The trophy's inscription reads: "For its magnificent entry—combining unique conception with excellent execution." The float's magnet symbolized Burbank's knack for attracting people from across the world. (BTORA.)

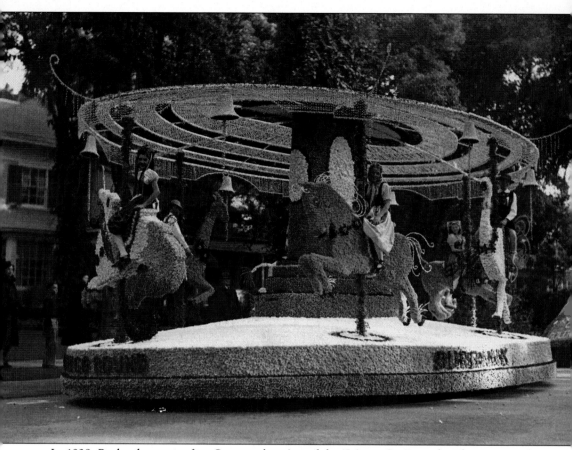

In 1938, Burbank won its first Sweepstakes Award for "Merry Go Round." The Sweepstakes Award—the parade's top prize—is granted to the "most beautiful and appropriate float" in all non-commercial divisions. Gorgeous white narcissus drape the canopy, while six schoolchildren ride atop red-, yellow-, blue-, and white-blossomed animals. In a team effort, the float was built by the Burbank Public Schools for $700. Teachers began planning for the float in April 1937. By September, art classes had prepared sketches, scale drawings, and a float model. The six animals were built by junior high shop classes, while the canopy and framework were constructed by high school students. Sewing classes used airplane cloth to cover the carousel animals, and home economics students designed the merry-go-round riders' attire. With the help of science classes, the float even had its own music playing as it passed spectators. Before its big debut, journalism students wrote float descriptions for the press. (BTORA.)

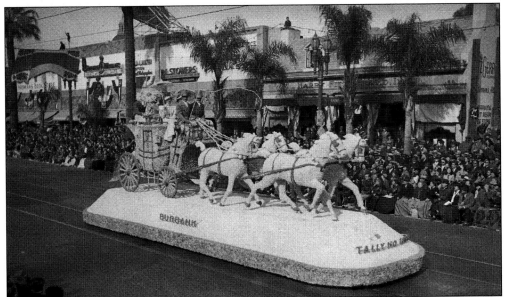

In 1939, Burbank won its second Sweepstakes Award for "Tally-Ho of 1889," aptly named to honor the year the Tournament of Roses Parade began and to celebrate its 50th anniversary. The float featured four galloping white horses pulling a pink flower–adorned carriage. Local craftsmen looking for work during the Depression helped create this float. Tournament officials dubbed it the most "outstanding float" in the "all-time history of the Tournament of Roses." The students riding the float are Pearl Ramgren, Nancy Hungate, Marguerite Harp, Al Cooper, Elmer Forsyth, Paul Burkhart, and Leo Burt. Construction on the float, shown in the photograph below, was done by teachers and students of the Burbank Public Schools, who were led by Alice DeHater. (Both, BTORA.)

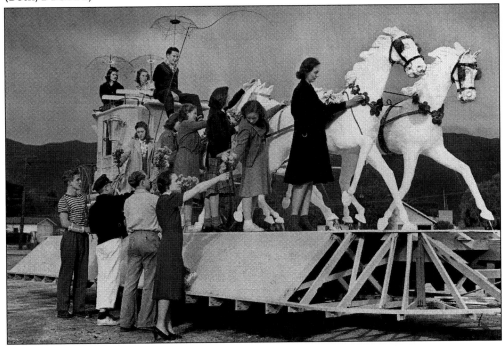

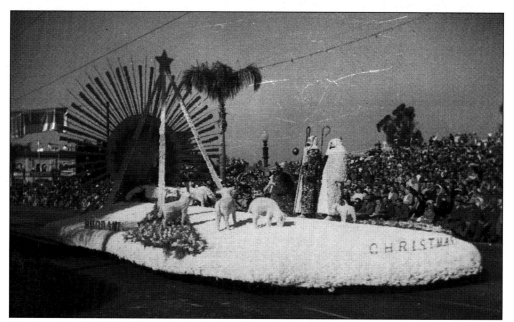

The legendary Isabella Coleman, who designed over 250 award-winning Rose Parade floats during her career, designed Burbank's 1947 Theme Prize winner, "Christmas—The Nativity." The float represented Christ's birth, complete with Mary, a lamb, a donkey, sheep, and three wise men. Today, the Rose Parade has an award named the Isabella Coleman Trophy, which is presented to the float with flowers displaying the best color harmony. (BTORA.)

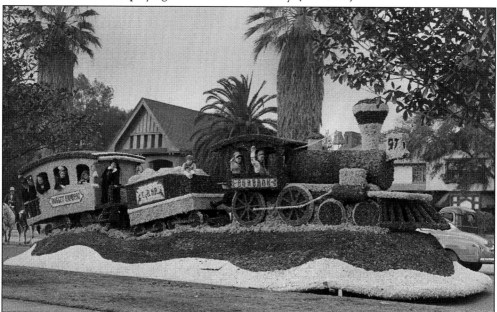

In 1948, the newly formed Burbank Tournament of Roses Association debuted its first float, "Nugget Express." The train transported 8- to 11-year-olds Nancy Bowers, Janice Ross, Patty Emrick, Richard French, Wallace Cooper, Billy Murray, Dennis Richardson, and Scott McClengon. Unfortunately, the float never made the journey back to Burbank for viewing on January 3 because it was damaged on the way to the parade by a drunk driver. (BTORA; photograph by Paul E. Wolfe.)

Love was in the air in 1949 as "First Love" snagged First Prize in the competition between cities with populations between 50,000 and 200,000. It was not an easy win, though; a frost interfered with flower orders, the float's highlight—a real tree—was mistakenly cut for firewood, and a power outage left decorators in the dark just two days before the parade. Nevertheless, Burbankers pulled together, donated homegrown flowers, and came out winners. (BTORA.)

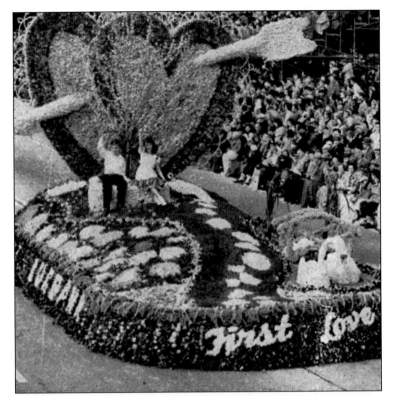

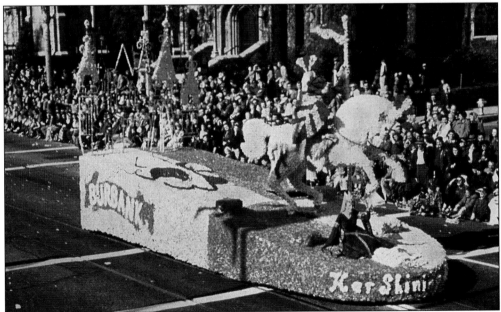

In 1952, "Her Shining Knight" won First Prize among cities with populations between 75,000 and 90,000. The float featured a knight—made of 5,000 silver tree leaves and 500 lanaria—riding a horse bedecked with 5,000 white pompoms. A castle made of 1,500 yellow pompoms, 500 lanaria, and 500 pink carnations brings up the rear, while Burbank high school student Ann Dyer sits at the front dressed in medieval attire. (Roy Skaggs/BTORA.)

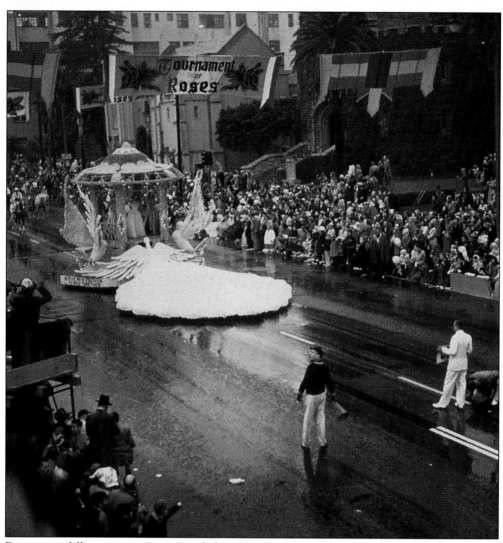

During rainfall, a rarity in Rose Parade history, two parade officials direct "Birds of a Feather Flock Together" to its mark for the 1955 Theme Prize photograph. Carnations, gladioli, sweet peas, orchids, and roses decorate the float, while a pink- and white-flowered gazebo, surrounded by an extravagant white peacock and two white swans, carries three float riders: Shirley Reigers (center)—Miss Burbank of 1954—and her princesses, Gay Shoman and Dixie Freeman. Reigers, although soaked and cold from the rain, was elegantly dressed in a gown once worn by Doris Day. The gown was loaned to Reigers by Warner Bros. (Roy Skaggs/BTORA.)

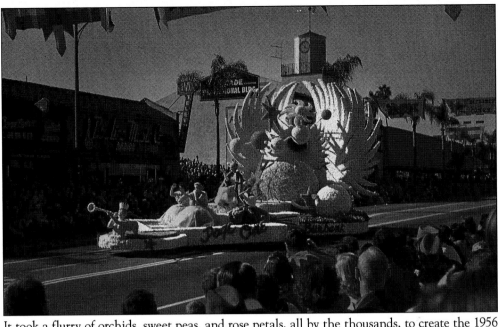

It took a flurry of orchids, sweet peas, and rose petals, all by the thousands, to create the 1956 Sweepstakes winner "Page One." Designed by Mary Schuster, it depicted the creation of the universe. The float riders are, from left to right, Cynthia Kroesen, who represented white pure air; Gail Schueltage (blue water); and Donna Young (green earth). A surprise rider, Italian actress Rossana Podestà, was atop the pedestal. After the parade, Podestà, the star of *Helen of Troy*, signed more than 600 autographs, leaving her with a considerable case of writer's cramp. In the photograph below, viewers take in the beauty of "Page One" at the post-parade show. The float, which was 17 feet high, 20 feet wide, and 46 feet long, was constructed on a truck chassis powered by a GMC engine. (Above, Roy Skaggs/BTORA; below, Theodore Kross/BTORA.)

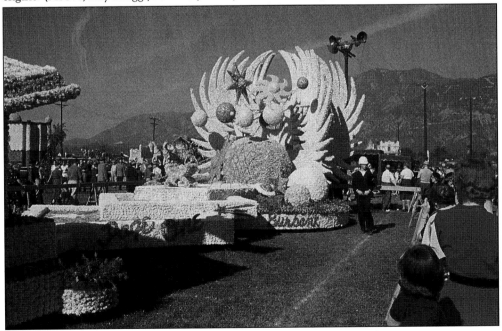

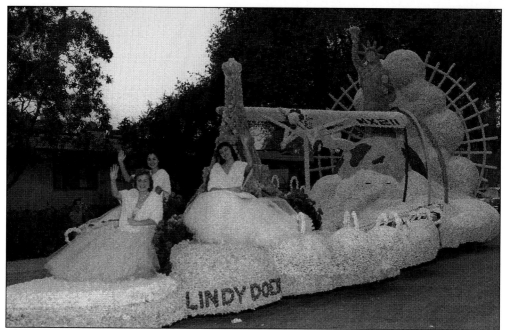

In 1957, there were firsts all around. "Lindy Does It," which commemorated Lindbergh's first solo transatlantic flight from New York to Paris, won First Prize (Class A-7 division). In this image, Carol Uptgraft, Martha Dragna, and Dolores Medina are waving in front of the Eiffel Tower. Designed by Phil Jeffries, the float measured 16 feet high, 20 feet wide, and 45 feet long. (BTORA.)

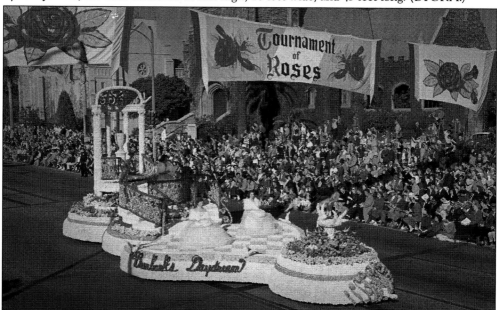

"Burbank's Daydream" captured the city's fourth Sweepstakes Award in 1958. The float was decorated with 22,000 vanda orchids. Other complementary blooms included thousands of roses and azaleas. The float, which cost nearly $8,000, featured a staircase that led to a lush garden and a golden trophy prominently placed atop a pedestal. Over 1.5 million people were in attendance to see Burbank's beauty. (BTORA.)

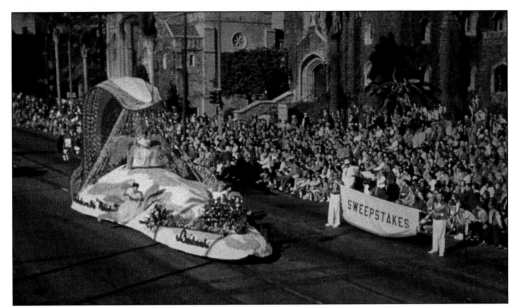

Pictured here gliding down Colorado Boulevard in front of over 1.7 million people, the 50-foot-long "Orchids in the Moonlight" won Burbank's fifth Sweepstakes Award in 1961. Its enormous, 25-foot cantilever canopy was adorned with orchids. Over 170,000 flowers were used, including 77,000 white chrysanthemums and 34,000 pink chrysanthemums—all applied by Burbankers the weekend before the show. Riding the float are Diana Ferber, Joren Coates, and Karen Lindner. (Roy Skaggs/BTORA.)

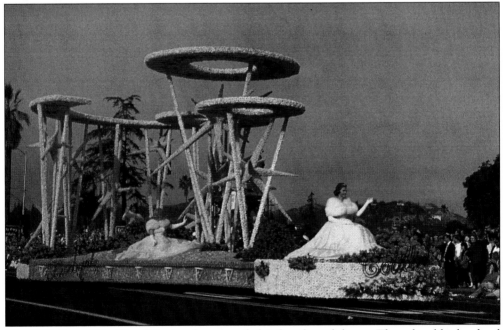

The 1963 float, "Cotillion," depicted a young lady's first formal dance. Three local high school seniors were chosen to ride atop the float: Susan Smith, Jane Savo, and Diane Walcott, all outfitted in formal gowns and furs. The float, covered predominately in yellow and white mums, included a floral garden and golden stars twinkling above. (Roy Skaggs/BTORA.)

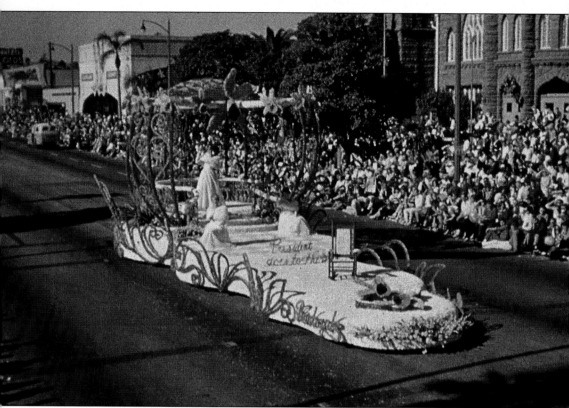

The 1964 float, "President Goes to the Prom," commemorated the late John F. Kennedy and his visit to the John Burroughs High School prom. On June 7, 1963, Burroughs's graduates planned to celebrate their prom in the Grand Ballroom of the Beverly Hilton Hotel in Beverly Hills. Weeks before the gala, their reservation was bumped because the Democratic Party scheduled a fundraising dinner—which JFK was to attend—for the same day and location. When Kennedy found out their prom was in jeopardy, he let the students use the Grand Ballroom and moved his dinner to a smaller room upstairs. As a thank you, the students invited Kennedy to the prom, not knowing he would attend. Over 170,000 flowers were used to re-create this notable experience. Outfitted in white gowns fit for a prom are John Burroughs High School students Ginny Rollins, Jeri Thompson, and Linda Hughes. They pose under elegant chandeliers made of white mums, which hang in an orchid ballroom. A brown rocking chair, reminiscent of the one Kennedy had in his Oval Office, is featured at the front. (Roy Skaggs/BTORA.)

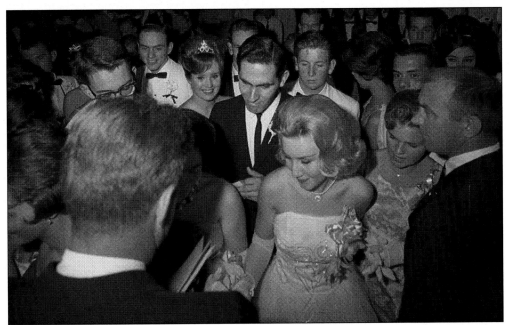

John F. Kennedy (at lower left in the image above) meets with the graduates of John Burroughs High School in the Grand Ballroom of the Beverly Hilton Hotel in Beverly Hills on the evening of June 7, 1963. In the photograph below, Jack Benny (left) listens while Kennedy makes a lighthearted speech to the graduating class. A White House sound recording captured Kennedy as he joked, "Next to being president—in fact, rather than being president—I'd prefer to be a senior in this high school, and if Mr. Benny and I are not too old, we may apply." Kennedy wished the students "the best of success" and eloquently stated, "All that this country is, all that it hopes to be, is right in this room tonight." (Both, Cecil Stoughton. White House Photographs. John F. Kennedy Presidential Library and Museum, Boston.)

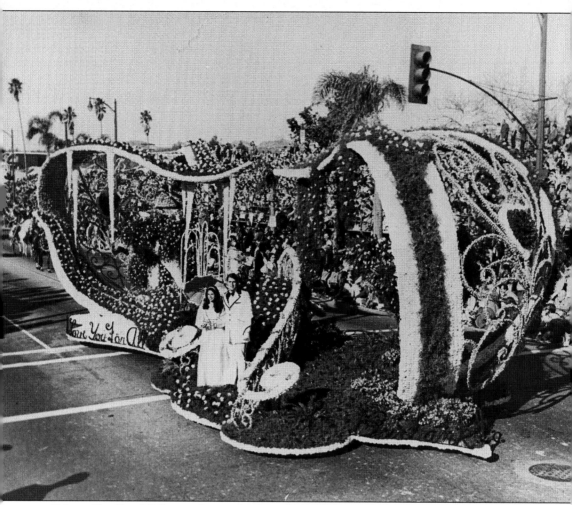

"I Love You For All Seasons" won the Grand Marshal's Trophy in 1972 for its superior design and innovative concept. Representing spring and summer are Sharri Matalon (left), who wore a yellow dress, and Clark Jellison, outfitted in a white suit. Winter and fall were represented by float riders Bill Birtell, dressed in a dark grey suit, and Gina Gutru, fitted in a white coat (they are not pictured). Designed by Art Aguirre, the float measured 18 feet wide, 50 feet long, and 16 feet high. Borrmann Steel Company (located at 110 West Olive Avenue) provided complimentary steel for the float's frame, which was assembled by city welders. Dozens of local teenagers volunteered time to build and decorate the float. It was decorated with 550,000 flowers, including vanda orchids, roses, and mums, plus a working water fountain, which happened to stop operating on parade day. (Bill John/BTORA.)

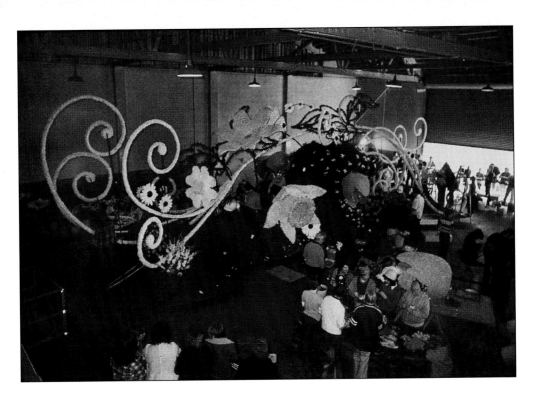

In 1976, "Let's Celebrate America's Natural Beauty" took First Prize among cities with populations between 85,000 and 100,000. This photograph was taken in the BTORA Float Barn during decoration week in December 1975. The float was accented with animated fluttering butterflies, powered by windshield-wiper motors, and two functioning seven-foot waterfalls. Prior to the first judging, Ty-D-Bol cleaner was added to the waterfalls because the water had gotten stale, causing an unpleasant aroma. Although this might have fixed the smell, the cleaner foamed up as it passed through the water pump, leaving foam everywhere and float volunteers scrambling to clean up suds as the judges entered. The photograph below shows the rendering of "Let's Celebrate America's Natural Beauty," designed by Clark Jellison, who has designed seven floats for the city. (Above, Roy Skaggs/BTORA; below, BTORA.)

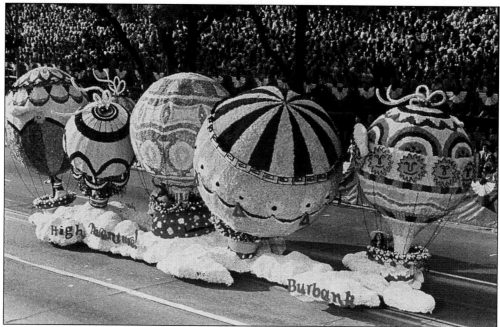

Many hues of carnations, roses, mums, and fresh fruits decorate the 1977 Founders' Trophy winner, "High Adventure!" Six steel-structured hot air balloons float above puffs of chrysanthemum clouds. Designed by Burbank resident Clark Jellison (his fourth design for Burbank), the float encompassed the parade's theme, "The Good Life." (Roy Skaggs/BTORA.)

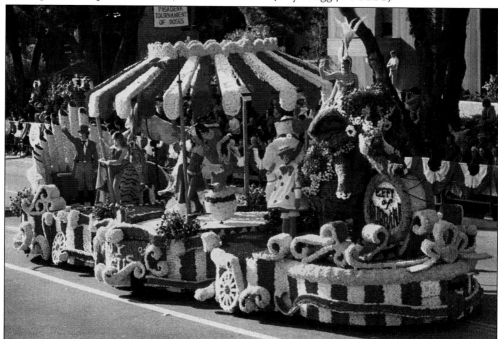

"Joy of the Circus" won First Place (Class A-6 division) in 1983. Raw cotton was used for the circus bears' fur, and 200 pounds of lettuce seeds served as the elephant's skin, while pampas grass and hyacinth root covered the other "wild animals" at the circus gala. (Lori Valesko/BTORA.)

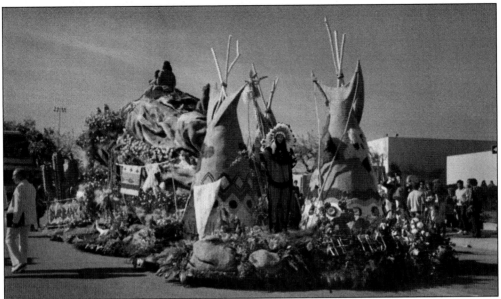

In the image above, smoke signals blast from the 1988 float, "The First Hello," to greet the crowd. Embracing the parade's theme, "Thanks to Communication," the float included two teepees and riders costumed as a Native American tribe: Erik C. Andersen (chief), Mary Jane Hibbard, Elaine Kemp, Alex Garcia, Paula Peterson, Graunya Holsen, and Mac Peebles. Designed by Keith Kaminski, the float measured 32 feet long and 18 feet wide. In the photograph below, Kaminski (right) and Wayne Smith hold a sheet over the top of a fire pit to test the float's smoke signal feature. A fog machine, run by five people, was positioned inside the pit. Once the smoke gathered at the top of the pit, the sheet was lifted, allowing the smoke to erupt in a puff. (Both, Erik C. Andersen/BTORA.)

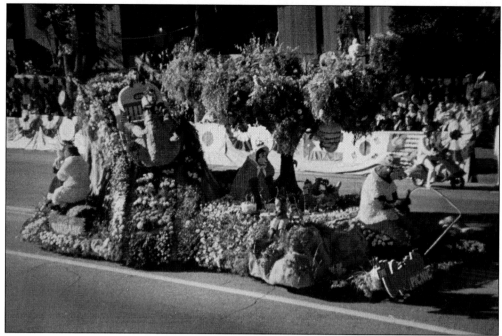

On January 1, 1989, "The Unforgettable Picnic" made its way down Colorado Boulevard in Pasadena's Tournament of Roses Centennial Celebration. Designed by Erik C. Andersen, the 35-foot float featured Mama Bear, Papa Bear, and the kids as they coped with unexpected blunders during their New Year's Day picnic. Its use of animation was Burbank's most ambitious yet: two bears kiss, a car driven by Baby Bear zips up and down a hill, and a buzzing bee circles above Grandpa Bear, who is sound asleep. Andersen's rendering (below) was created with colored ink pens, whiteout, and watercolors. (Above, BTORA; below, Erik C. Andersen/BTORA.)

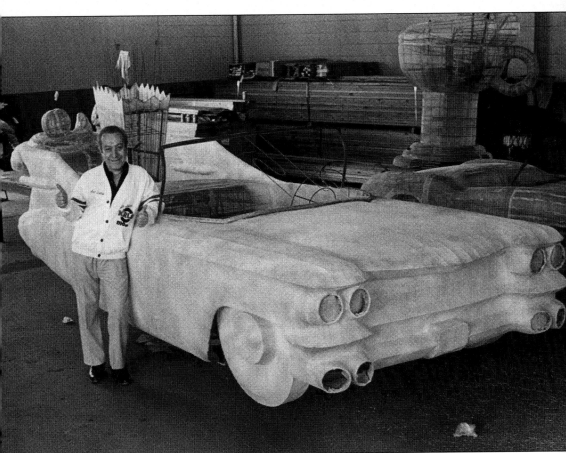

Radio icon Art Laboe gives a thumbs-up as he poses next to a cocooned Cadillac at the BTORA Float Barn at 123 West Olive Avenue. This photograph was taken during construction for the 1990 float, "The Harmony of the 50's." The car beside Laboe was built with steel rod wire, which was then covered with window screen. In a technique called cocooning, a glue-like substance was used to fill the pores of the screen. Afterward, the car was painted the color scheme of the flowers that volunteers would affix during decoration week. On parade day, Laboe rode the float and brought the party to life by broadcasting a special lineup of 1950s tunes. Laboe, who coined the phrase "Oldies But Goodies," was the first DJ to broadcast rock and roll music on the West Coast. He received a star on the Hollywood Walk of Fame in 1981 and was inducted into the National Radio Hall of Fame in 2012. (Erik C. Andersen/BTORA.)

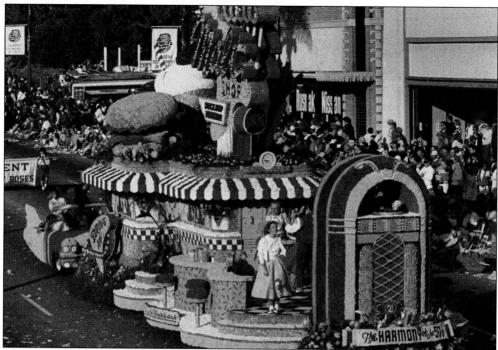

From "Shake, Rattle, and Roll" to "Tutti Frutti," oldies blared from a vintage jukebox on the 1990 float, "The Harmony of the 50's," which won a Pioneer Trophy. Fifteen dancers move to the beat on a guitar-shaped dance floor, while teenagers drive up to the Be-Bop Malt Shop and order from a roller skating waitress. Legendary 1950s DJ Art Laboe was on the float and on the microphone; Laboe broadcast live on KRLA 1110 AM, a first in parade history. In the image above, Laboe is visible at the front of the float behind the dancer wearing a poodle skirt. The float measured 55 feet long and 22 feet tall, making it Burbank's biggest yet. The rendering of the float (below) was designed by Brad Jensen and Keith Kaminski. (Above, BTORA; below, Erik C. Andersen/BTORA.)

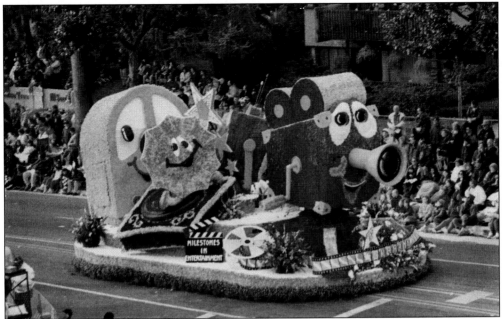

In 1993, "Milestones in Entertainment" commemorated the entertainment industry's early years. Complete with a microphone, a gramophone, a television, a radio, and a vintage hand-cranked movie camera, the float exhibited Burbank's deep roots in the media industry. The float had its own original song, "Be Entertained," and captured the parade's overall theme, "Entertainment on Parade," which embraced art, music, literature, movies, television, and sports. The postcard below shows the float's rendering designed by Ron Cooper. (Above, Erik C. Andersen/BTORA; below, BTORA.)

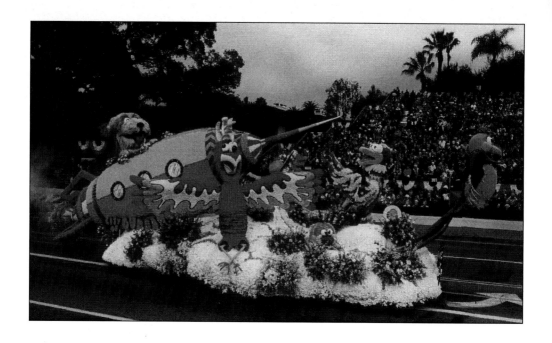

The 2000 float was the Mayor's Trophy winner, "To the Future . . . At Full Throttle!" A pup made with bulgur, cocoa palms, pampas, and uva grass jets off to the new millennium on a rocket made of 6,000 carnations, 8,500 yellow mums, 300 cattleya orchids, and an array of lentils, fruits, and spices. A hydraulic pump and an 8,000-watt A/C generator powered by a propane engine were used to animate the dog's head, birds' wings, and rocket. When finished, the float measured 15 feet, 6 inches high, 18 feet wide, and 54 feet long. Below is the sketch for the float, which was designed by Clark Jellison. (Both, BTORA.)

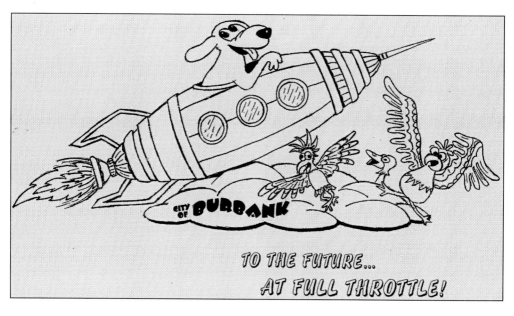

In the 2010 photograph above, sparks fly as Ric Scozzari, Burbank sculptor and artist, welds a tire frame for the 2011 "Centennial Celebration" float. "Centennial Celebration" was designed by Burbank resident Julio Leon. The image below shows the final rendering, which took several drafts and revisions. Every detail was considered and reviewed by the Burbank Tournament of Roses Design Committee. For instance, one of the sketches for Johnny Carson, who was to be displayed on the filmstrip along the bottom of the float, had to be changed because the part in Carson's hair was going the wrong way. (Above, Ron Olzick/BTORA; below, BTORA.)

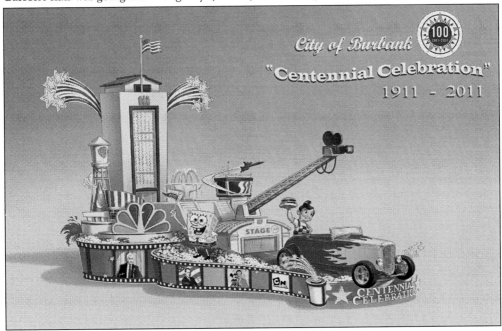

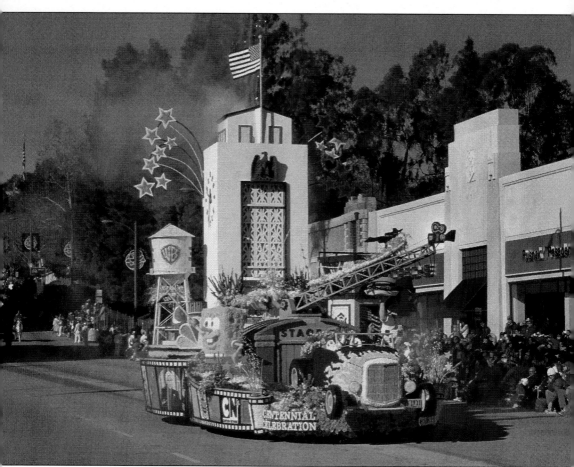

This January 1, 2011, photograph shows "Centennial Celebration," which honored Burbank's 100-year anniversary of its July 8, 1911, incorporation. Measuring 43 feet long, 18 feet wide, and 31 feet tall, the float represented all aspects of Burbank—it included floragraphs of Bob Hope and Johnny Carson, a city hall made of sweet rice and ground coconut, a corn-husked Warner Bros. water tower, and the Bob Hope Airport Tower decked in oatmeal, ti leaf, and ming moss. It took more than 650 volunteers—both locals and visitors—to apply more than 60,000 flowers onto the float, which included 19,000 roses, 12,000 carnations, and 25,000 mums. The float featured fireworks, music, and prominent float riders Burbank mayor Anja Reinke and former city manager Mary Alvord. The float won the Founders' Trophy and kicked off the city's yearlong centennial celebration. (Erik C. Andersen/BTORA.)

*Five*

# As Time Goes By

Memories keep the past close. Diaries, photographs, newspaper articles, and sound recordings can also capture fleeting moments in time. Throughout the city, hidden pieces of Burbank's past are packed away into time capsules set to be opened decades later. When revealed, Burbankers can see what time has done, what has changed, and how the years have transformed the city.

In February 2009, Burbankers saw time's effect when they unearthed a small silver-plated time capsule from 1959. Stowed in the Magnolia Boulevard Bridge, it contained a 35-mm film negative of nearly 50 black and white images of the city, including Burbank High School, Burbank Public Library, city hall, and Lockheed Air Terminal.

During the national bicentennial in 1976, one of the city's many time capsules was placed under the sculpture of Dr. David Burbank in Central Library's courtyard. Newspaper clippings, bicentennial license plates, and city booklets were all sealed away in a capsule that is not to be opened until 2051.

In 2011, a time capsule containing memorabilia from the city's 100-year celebration was buried near the front steps of city hall. Dedicated to the citizens of Burbank, it is to be opened during Burbank's bicentennial celebration in 2111.

Burbankers of today can only guess at what the city may look like in 100 years. The photographs in this chapter offer a glimpse of the past juxtaposed with the present, giving readers a look at what time has done, up until now, to some of the city's historical sites.

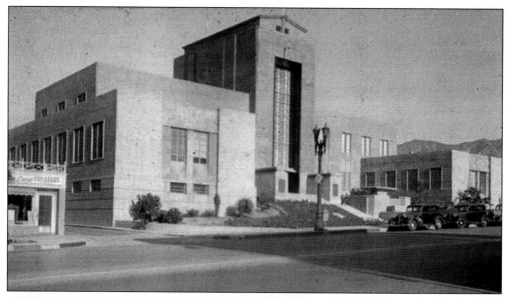

With help from the Works Progress Administration (WPA), the City of Burbank built a new city hall on Olive Avenue in 1943. The Art Deco structure, designed by George W. Lutzi and William Allen, is visible in this 1940s photograph. The building still stands today and is shown in the recent photograph of city hall pictured at left. On April 18, 1996, the property was listed in the National Register of Historic Places. (Above, WC,MM/Burbankia; left, EJS.)

The post office, pictured here around 1911, was located in the Burbank Block (the city's first brick building) at the corner of San Fernando Boulevard and Olive Avenue. In 1887, the town's post office was located in a barn on Orange Grove Avenue, where it was also home to a market and a boardinghouse for Burbank Villa construction workers. (WC,MM/Burbankia.)

This downtown post office, built in 1937 at 135 East Olive Avenue, is still in the same location today. The building was named in honor of Bob Hope on November 11, 2003, and listed in the National Register of Historic Places in 1985. (EJS.)

In the image above, police and fire staff pose for a group photograph in the 1930s. In 1913, the city took control of an all-volunteer fire department. By 1916, the city bought its first fire truck, and the firefighters were paid for each fire mission. In 1911, the city marshal's office was in charge of law enforcement. In 1923, the city marshal's office became the Burbank Police Department, with a crew of less than 10 officers. The image at left offers a present-day look at the Police and Fire Headquarters, which opened in 1998 on the corner of Orange Grove Avenue and Third Street. A commemorative statue outside reads: "Burbank's Public Safety Professionals—dedicated to protecting lives and property while serving our community." (Above, WC,MM/Burbankia; left, EJS.)

This photograph, taken outside the Central Library on September 19, 1975, shows the Pomeroy family as they gather around a sculpture, designed by Henry Van Wolf, of Pres. Abraham Lincoln in meditation. Pictured here are Mr. and Mrs. Richard Pomeroy, Helen Pomeroy Sullivan, Frances Muir Pomeroy, Margaret Pomeroy, Mrs. Charles Pomeroy, Vance Pomeroy, Mr. and Mrs. H. Greenam, Charles Pomeroy, and May Fox Pomeroy. The sculpture (right), given to the city by Frances Muir Pomeroy, stands at the entrance to Abraham Lincoln Park at the corner of Buena Vista Street and Verdugo Avenue. (Above, WC,MM/Burbankia; right, EJS.)

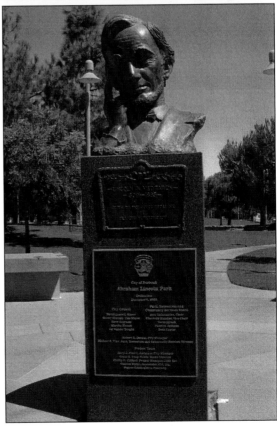

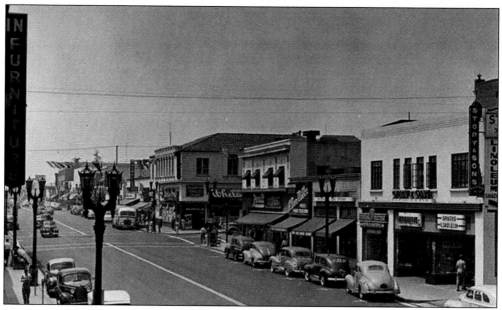

The vintage photograph above shows San Fernando Boulevard in the late 1940s. Story & Sons hardware store (right foreground) was a thriving business at the time. Much has changed over the decades. The image at left offers a current look at San Fernando Boulevard between Angeleno and Olive Avenues. Story Tavern is now located at the site where Story & Sons once stood. A plaque outside Story Tavern commemorates Thomas Story, the city's first mayor and the longtime owner of Story & Sons. The downtown district that once contained dirt roads, horse-drawn carriages, and sheep crossings has bloomed into a bustling hub that attracts locals and tourists alike. (Above, WC,MM/Burbankia; left, EJS.)

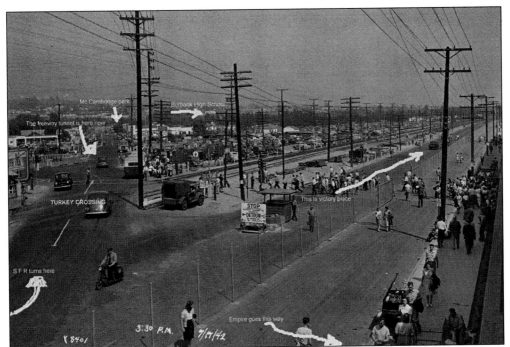

This annotated 1942 photograph shows the busy intersection aptly named Turkey Crossing (where San Fernando Boulevard crossed the railroad tracks near Empire Avenue). In December 1899, rancher Daniel Curtis attempted to cross these tracks on his way to deliver a wagon full of Christmas turkeys to Los Angeles. A train coming from San Francisco crashed into his wagon, sending turkeys flying far and wide and spoiling his holiday trades and dinners for the locals. Luckily, Curtis survived the incident. Today, Turkey Crossing is a bit hidden, as it lies where San Fernando Boulevard passes under the freeway. The photograph below shows the point where San Fernando and Victory Place split. A driver taking San Fernando Boulevard through the freeway tunnel will pass the area known as Turkey Crossing. (Above, WC,MM/Burbankia; below, EJS.)

117

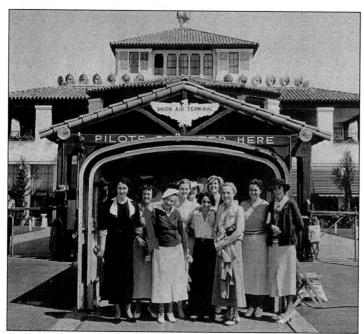

Pilots from the southwest chapter of the 99s gathered for this photograph, which was taken sometime between 1934 and 1940 at Union Air Terminal. The 99s, an international organization composed of female pilots, was founded by 99 licensed female pilots on November 2, 1929, with Amelia Earhart serving as the first president. After more than 80 years, the organization still exists today. (Katherine Smith/GoDickson.com.)

Ceci Stratford, member of the San Fernando Valley 99s, stands with her plane at the French Valley Airport in this January 2010 photograph. Stratford, a former Burbank resident, has been flying for over 37 years. Some of her many prestigious awards include the Amelia Earhart Scholarship (1985), two Trixie Schubert Service Awards (1980, 2013), and the Southwest Section 99s Woman Pilot of the Year (2005). Stratford, who has flown over 700 children (Young Eagles), also mentors student pilots. (Ceci Stratford.)

Anastasia "Stacie" Vournas has been a member of the San Fernando Valley 99s since 2002. Vournas, a teacher at John Muir Middle School, is a certificated flight instructor with nearly 1,500 hours of flight under her belt. From 2004 to 2009, Vournas earned Rookie Pilot of the Year, Woman Pilot of the Year, the Trixie Schubert Service Award, and the Amelia Earhart Scholarship. This 2011 photograph captures Vournas as she flies traffic watch for KFWB/KNX. (Anastasia Vournas.)

Jackie Forsting, Burbank resident and former member of the San Fernando Valley 99s, is a certificated flight and ground instructor. Forsting currently teaches the Aviation Explorers Post 747 at Whiteman Airport and also is an instructor at Van Nuys Airport. In this March 2009 photograph, Forsting, who also competes in primary aerobatic competitions, is flying home in a Pitts S2B from the El Centro Air Show, where she serves as crew chief. (Spencer Suderman.)

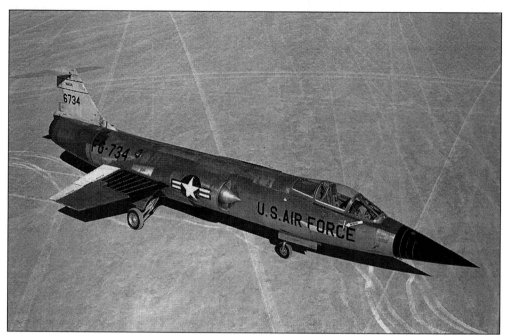

Created by Collier Trophy winner Clarence L. "Kelly" Johnson and Skunk Works, the Lockheed F-104 Starfighter made its first flight in 1954 and was produced until 1979. During that time, the company manufactured 2,583 Starfighters—including over 20 different models. In the image above, an F-104A sits at Rogers Dry Lake at Edwards Air Force Base on November 16, 1960. The photograph below shows an F-104D Starfighter displayed at George Izay Park. This Starfighter—*Spirit of Burbank*—measures 54.8 feet long and 13.5 feet high and has a wing span of 21.9 feet. (Above, NASA Dryden Flight Research Center; below, EJS.)

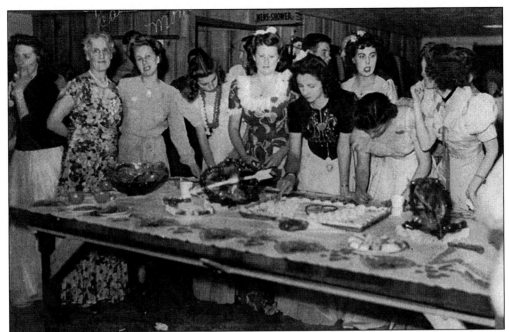

In the 1943 image above, partygoers gather for a Valentine's Day dance at the USO center located on San Fernando Boulevard. According to the USO, in February 1943, the organization was providing servicemen by the thousands with recreation and social activities. One month later, in March 1943, Glenn Trout ran two USO centers. With its headquarters at Olive Avenue Park (George Izay Park), the USO provided leisure activities for both military members and those in the community. The former USO headquarters is now the Olive Recreation Center (below). (Above, WC,MM/Burbankia; below, EJS.)

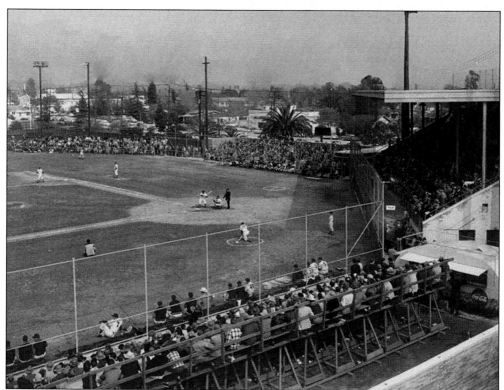

In this early-1950s photograph of Olive Memorial Stadium, fans fill the stands to watch the St. Louis Browns hit some balls during spring training. Crowds of up to 2,500 people flocked to the stadium, including celebrities such as Marilyn Monroe and Bing Crosby. The Browns used Olive Memorial Stadium for spring training from 1949 to 1952. (WC,MM/Burbankia.)

Olive Memorial Stadium, built in 1946, had its field graced by baseball greats including Baseball Hall of Fame pitcher Satchel Paige; 12-time Gold Glove Award winner and Baseball Hall of Famer Willie Mays; Baseball Hall of Fame second baseman and 1952 Browns manager Rogers Hornsby; and Bobby Thomson, who hit the home run known as the "shot heard 'round the world" in the 1951 National League pennant game. (WC,MM/Burbankia.)

Olive Memorial Stadium was dedicated in 1947. It stood for more than 45 years and was torn down in 1995 because of structural deterioration. This memorial, made of pieces from the original Olive Memorial Stadium and its plaques, stands at 1100 West Olive Avenue. (EJS.)

After Olive Memorial Stadium was destroyed, a new Burbank City Stadium was dedicated on October 5, 1996, at George Izay Park, the former site of Olive Memorial Stadium. The park contains Lloyd "Lefty" Thomas Field, Bill Burton Field (pictured), Jack Smock Field, and Barbara Rownd Field. (EJS.)

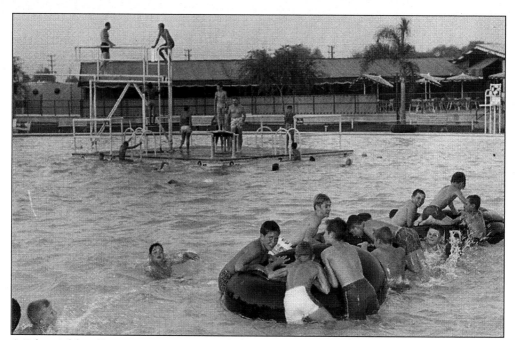

A Police Athletic League group enjoys a pool party at Pickwick Recreation Center in the 1950s. The center, located on Riverside Drive, offered swimming, ice skating, bowling, dancing, and dining. In the 1940s, a $2.5-million, 14-acre amusement center—Pickwick Playland—was proposed at Riverside Drive and Mariposa Street. Plans never materialized, even with the support of celebrities such as Frank Sinatra and Mickey Rooney. (WC,MM/Burbankia.)

Pickwick still stands today, although its name has changed to Pickwick Gardens. In the mid-1980s, the swimming pool was replaced with vibrant gardens (pictured), which play host to weddings, banquets, and conferences. (EJS.)

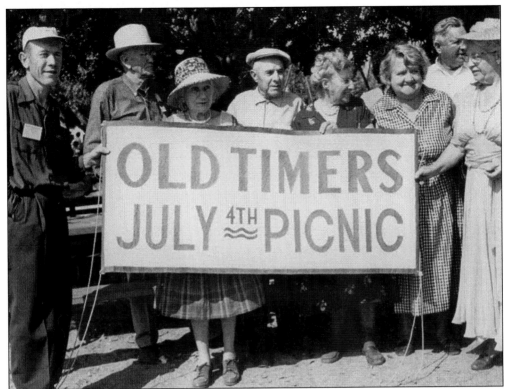

Above, a group of seniors celebrates Fourth of July with a picnic at McCambridge Park in 1961. McCambridge Park is named after James H. McCambridge, former general manager of the Public Service Department (1925–1952) and city manager (1952). McCambridge was actively involved in creating parks throughout Burbank. McCambridge Park still offers plenty of areas for people to enjoy. The photograph below shows one of the park's airy picnic spots off Amherst Drive. (Above, WC,MM/Burbankia; below, EJS.)

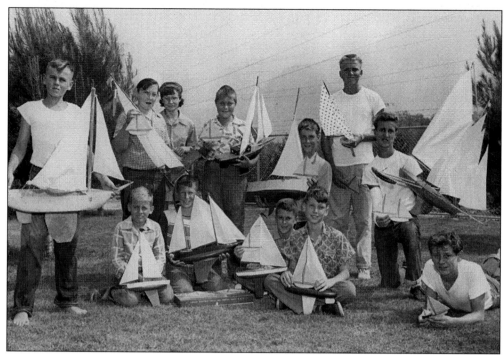

Participants from the Sailboat Regatta show off their ships near the casting pool at Buena Vista Park on August 20, 1954. Buena Vista Park, named in June 1943, was renamed Johnny Carson Park on April 29, 1992, in tribute to the *Tonight Show* host. Today, the beautiful, charming park (below) is home to exercise trails, relaxing picnic areas, and the Tonight Show Playground, which was funded by the Jay Leno Foundation and the Youth Endowment Service Fund. (Above, WC,MM/Burbankia; below, EJS.)

Glen Duckworth, Burbank resident, shows off the century plant that towers in front of her home in this August 30, 1952, photograph. Duckworth, who planted the enormous agave 35 years before in 1917, was awaiting the single bloom of the plant's life—a purple flower that lives for a mere four hours. Unfortunately, Duckworth's century plant never bloomed because of earthquake aftershocks. Normally, after a decade or more—not quite a century, despite the name—the plant shoots a tall stalk, measuring 20 to 30 feet in height, which bears its only bloom. As time goes by and as each decade passes, a new century plant blooms in a cycle similar to that of a city, which blooms, transforms, and changes over time. (United Press Photograph.)

# DISCOVER THOUSANDS OF LOCAL HISTORY BOOKS
## FEATURING MILLIONS OF VINTAGE IMAGES

Arcadia Publishing, the leading local history publisher in the United States, is committed to making history accessible and meaningful through publishing books that celebrate and preserve the heritage of America's people and places.

Find more books like this at
## www.arcadiapublishing.com

Search for your hometown history, your old stomping grounds, and even your favorite sports team.

Consistent with our mission to preserve history on a local level, this book was printed in South Carolina on American-made paper and manufactured entirely in the United States. Products carrying the accredited Forest Stewardship Council (FSC) label are printed on 100 percent FSC-certified paper.

MADE IN THE